PEN & INK

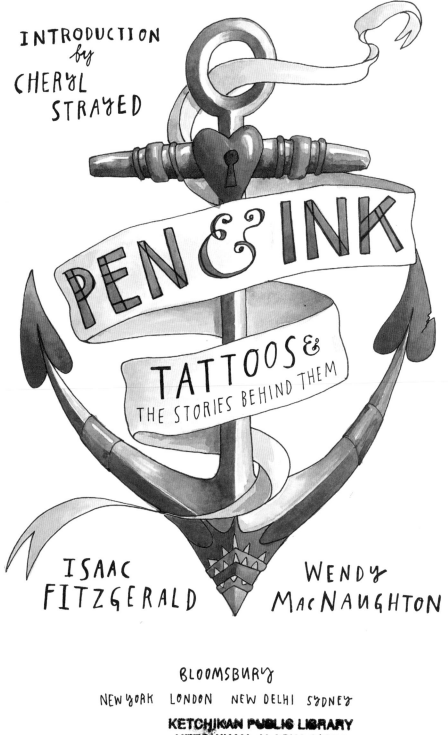

INTRODUCTION by CHERYL STRAYED

PEN & INK

TATTOOS &
THE STORIES BEHIND THEM

ISAAC FITZGERALD WENDY MacNAUGHTON

BLOOMSBURY

NEW YORK LONDON NEW DELHI SYDNEY

Published by Bloomsbury USA, New York
Bloomsbury is a trademark of Bloomsbury Publishing Plc.

All papers used by Bloomsbury USA are natural, recyclable products made from wood grown in
well-managed forests. The manufacturing processes conform to the environmental regulations
of the country of origin.

LIBRARY OF CONGRESS CATALOGING-IN-PUBLICATION DATA HAS BEEN APPLIED FOR.

ISBN: 978-1-62040-490-4

First U.S. edition 2014

1 3 5 7 9 10 8 6 4 2

Designed by Wendy MacNaughton

Printed and bound in China by C&C Offset Printing Co. Ltd

Bloomsbury books may be purchased for business or promotional use.
For information on bulk purchases please contact Macmillan Corporate
and Premium Sales Department at specialmarkets@macmillan.com.

TO TUMBLR and RACHEL FERSHLEISER,
WITHOUT WHOM THIS BOOK WOULD NOT BE POSSIBLE.

PEN & INK

PREFACE by ISAAC FITZGERALD

I FORGET THINGS. ALWAYS HAVE. AS A CHILD I COULD ALWAYS FIND MY MOTHER'S KEYS, BUT COULD NEVER REMEMBER WHERE SHE PARKED THE CAR. NEITHER COULD SHE.

AT THE AGE of FOURTEEN I WAS ACCEPTED at A BOARDING SCHOOL. FULL SCHOLARSHIP. APPLIED on MY OWN. AT SCHOOL, LIVING WITH BOYS from CAPE COD WHOSE FATHERS WERE DIPLOMATS and WHOSE MOTHERS THREW PARTIES in MANHATTAN, I WAS A POOR, NON-THREAT of A KID, BUT ONE WHO WAS ALWAYS READY to LISTEN. READY to BE THERE WHEN THOSE DIPLOMATS and MANHATTAN-PARTY-THROWERS DIDN'T VISIT. MY TALES of DRIVING TRUCKS THROUGH SMALL MASSACHUSETTS TOWNS, DRUNK and WITH NO LICENSE, MADE ME WHO I WAS. I LEARNED THAT PEOPLE DEFINE YOU BY YOUR STORIES.

SOPHOMORE YEAR WE WERE ALL HIGH as HELL. RITALIN, ADDERALL. ONE HUNDRED MILLIGRAMS at A TIME, UP OUR NOSE, CUT WITH OUR STUDENT I.D.s. OTHER DRUGS THAT WE'D BUY DOWNTOWN. WHISKEY STOLEN from THE TEACHERS' KITCHEN AREA. ANYTHING to PASS THE TIME.

OUR ADVISOR KNEW SOMETHING WAS UP. HE WAS ONLY TWENTY-FOUR HIMSELF, COVERED in TATTOOS, THE COOLEST TEACHER on CAMPUS. HE GATHERED US for A MEETING and HE MADE A RULE: GRADUATE from THIS SCHOOL and I WILL PAY for YOUR FIRST TATTOO.

OUT of THE SEVEN ADVISEES, I WAS THE ONLY to MAKE IT. EIGHTEEN YEARS OLD, in A TRAILER in NEW HAMPSHIRE in A TOWN FAMOUS for HAVING A NUCLEAR POWER PLANT and NOTHING ELSE, A MAN WITH A WALRUS MUSTACHE CUT A CELTIC TREE of LIFE INSIDE A TRIBAL SUN into MY SHOULDER. IT IS THE UGLIEST TATTOO I HAVE EVER SEEN. I WILL NEVER COVER IT UP.

YEARS LATER, WORKING at A BIKER BAR in SAN FRANCISCO, ALL WE DID WAS TELL THE STORIES of OUR TATTOOS. HERE'S THE CHILDHOOD FRIEND WHO LOVED SPORTS, TAKEN by CANCER, REMEMBERED WITH A SKULL and BONES MADE OUT of A BASEBALL and CROSSED BATS. THE CANDLE BURNING at BOTH ENDS, to REPRESENT THE NEED to WORK and THE NEED to NEVER SLEEP. A CHILD'S NAME, NOT SEEN for TEN YEARS, BACK WHEN HIS FATHER TOOK HIM and THE STATE SAID THAT THAT WAS OKAY. WE ARE OUR STORIES. AND TATTOOS ARE HOW WE REMEMBER NEVER to FORGET.

A TATTOO, WHETHER AN ORNATE FULL BACK PIECE OR A SCRATCHER JOB DONE IN SOMEBODY'S LIVING ROOM, IS ART. A PHOTOGRAPH of A TATTOO NEVER QUITE CAPTURES IT; HERE, ART REPRESENTS ART, ART REPRESENTING STORIES, STORIES REPRESENTING LIFE. BECAUSE EVERY-ONE, TATTOOS OR NO, HAS A STORY.

INTRODUCTION by CHERYL STRAYED

AS LONG AS I LIVE I'LL NEVER TIRE of PEOPLE-WATCHING. ON CITY BUSES and PARK BENCHES. IN SMALL-TOWN CAFES and CROWDED ELEVATORS. AT CONCERTS and SWIMMING POOLS. TO PEOPLE-WATCH IS to GLIMPSE THE MYSTERIOUS and THE BANAL, THE PUBLIC FACE and THE PRIVATE GESTURE, THE STRANGEST OTHER and THE MOST FAMILIAR SELF. IT'S to WONDER HOW and WHY and WHAT and WHO and HARDLY EVER FIND OUT.

THIS BOOK IS THE ANSWER to THOSE QUESTIONS. IT'S AN INTIMATE COLLECTION of PORTRAITS and STORIES BEHIND THE IMAGES WE CARRY on OUR FLESH in THE FORM of TATTOOS. THERE ARE PEOPLE WHO GOT TATTOOS BECAUSE THEY SURVIVED ILLNESS OR PRISON OR DEEP GRIEF. THERE ARE PEOPLE WHO GOT TATTOOS BECAUSE THEY LOVED PIZZA OR WHALE SHARKS OR BEING REMINDED of THEIR OWN MORTALITY. THERE ARE TATTOOS in HONOR of PARTICULAR DOGS OR RVs, DAUGHTERS and DADS, DRUNKEN NIGHTS and FRESH STARTS. SOME WERE MADE on THE SPUR of THE MOMENT UNDER EMOTIONALLY ADDLED OR CHEMICALLY IMPAIRED CONDITIONS; OTHERS, AFTER YEARS of CAREFUL PLANNING and CONSIDERATION.

EACH of THE STORIES IS LIKE BEING LET in ON SIXTY-THREE SECRETS by SIXTY-THREE STRANGERS WHO PASSED YOU on THE STREET OR SAT ACROSS FROM YOU on THE TRAIN. THEY'RE RAW and REAL and FUNNY and SWEET. THEY SPEAK of LIVES YOU'LL NEVER LIVE and EXPERIENCES YOU KNOW PRECISELY. TOGETHER, THEY DO THE WORK of GREAT LITERATURE—GATHERING A FORCE SO TRUE THEY ULTIMATELY TELL A STORY THAT INCLUDES US ALL.

1

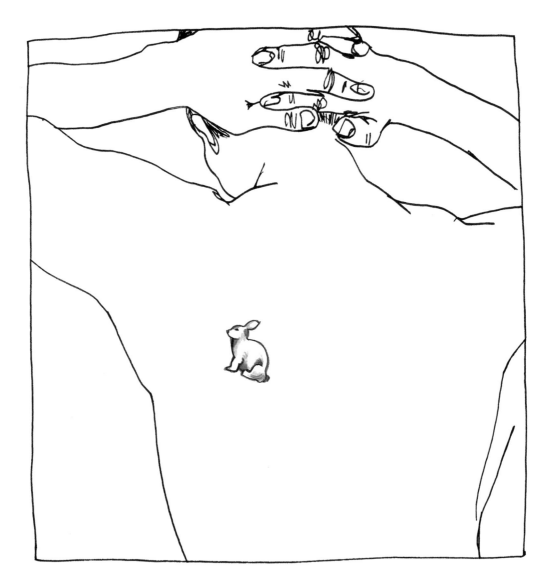

CHRIS COLIN, WRITER

I GOT THIS TATTOO BECAUSE I SUSPECTED ONE DAY
I WOULD THINK IT WOULD BE STUPID. I WANTED to
MARK TIME, OR MARK THE ME THAT THOUGHT IT WAS
A GOOD IDEA. SEVENTEEN YEARS LATER. I HARDLY
REMEMBER IT'S THERE. BUT WHEN I DO, IT REMINDS ME
THAT WHATEVER I THINK NOW I PROBABLY WON'T
THINK LATER. WHY A BUNNY? IT SEEMED LIKE MOSTLY
TOUGH TYPES WHO WERE GETTING TATTOOS at THE TIME.
I WANTED SOMETHING THAT WASN'T THAT.

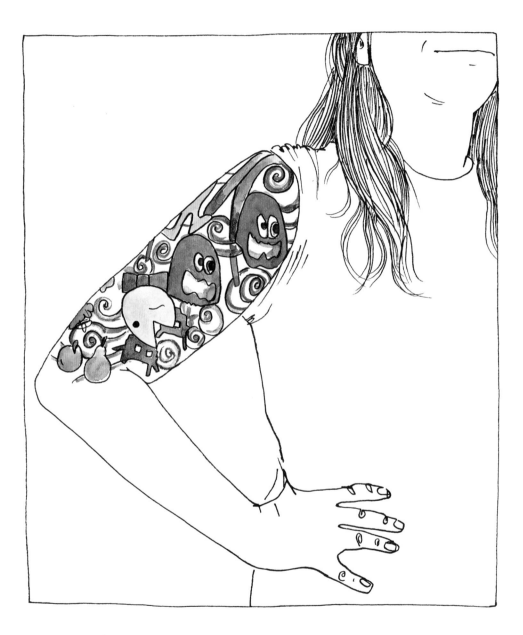

ANNA SCHOENBERGER, MANAGER at THRIFT STORE

WHEN I WAS 18 YEARS OLD I GOT THESE TATTOOS
as A TRIBUTE to MY GRANDMOTHER. I GREW UP
PLAYING VIDEO GAMES WITH HER. SHE HAD A COCKTAIL
TABLE WITH MS. PACMAN on IT WHERE WE WOULD PUT OUR
DRINKS or WE PLAYED for HOURS at A TIME. WE PLAYED
SUPER MARIO BROTHERS or WELL, but MS. PACMAN WAS
REALLY MY GRANDMOTHER'S GAME.

TO THIS DAY, WHENEVER I SEE MY GRANDMA, SHE
ALWAYS STARTS THE CONVERSATION by SAYING,
"PLEASE DON'T GET ANY MORE TATTOOS, ANNA." AND
EVERY TIME I RESPOND by POINTING at MY ARM and
SAYING, "I GOT THESE in HONOR of YOU, GRAMMIE
BEAR." AND THEN, EVERY TIME, SHE SAYS, "YOU'RE
SUCH A GOOD, GOOD GIRL," and SMILES.

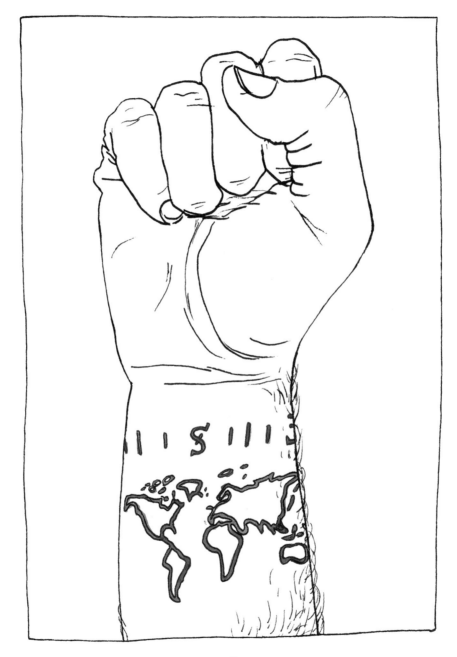

MIKAEL KENNEDY, TRAVEL PHOTOGRAPHER

A MAP of MY LIMITS.
THIS IS AS FAR AS I CAN WANDER.

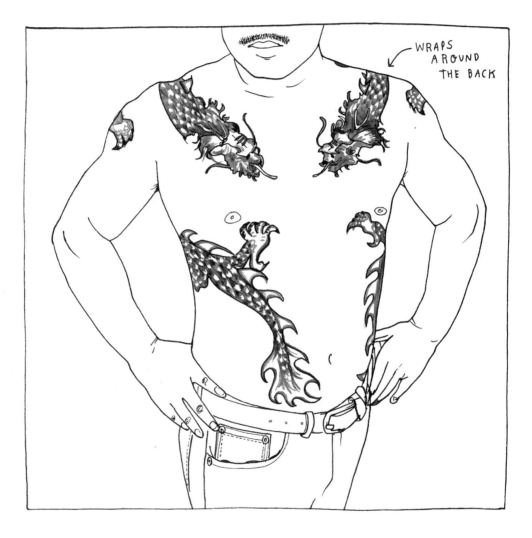

RAYMOND "SHRIMP BOY" CHOW, DRAGON HEAD of THE CHINESE FREEMASONS

I WAS SERVING ELEVEN YEARS in TEHACHAPI STATE PRISON for RACKETEERING. REALLY ROUGH THAT PLACE, A LOT of GANGS, BGF,* AB,** NORTHERN BOY, SOUTHERN BOY, CRIPS, BLOODS, TEXAS MOB. ONE DAY A KID NAMED 007 WHO RAN DRUGS for ME GETS STABBED in A RIOT. I CARRY 007 to THE PRISON HOSPITAL, but IT'S LOCKED BECAUSE of THE RIOT. I BANG on THE DOOR and YELL and FINALLY THEY DRAG HIM INSIDE.

007 COMES BACK and SAYS, RAYMOND, you SAVED MY LIFE, LET ME MAKE YOU A TATTOO. SO I ASK for A DRAGON. YOU KNOW HOW CHINESE LOVE DRAGONS. HE BREAKS A CASSETTE PLAYER to GET THE MOTOR to MAKE A TATTOO GUN. THE NEEDLE is A GUITAR STRING. FOR INK HE BURNS A BLACK PLASTIC CHESS PIECE and COLLECTS THE SMOKY ASH and ADDS INDIA INK and TOOTHPASTE. ARE you FUCKING SERIOUS, I SAY, YOU'RE PUTTING THAT FUCKING SHIT in MY BODY? WHOLE THING TAKES A MONTH. WITH A SINGLE NEEDLE you HAVE to GO SLOW and DEEP, NOT LIKE A TATTOO SHOP with MANY NEEDLES. THE PAIN WAS EVERYWHERE.

* BLACK GUERRILLA FAMILY
** ARYAN BROTHERHOOD

9

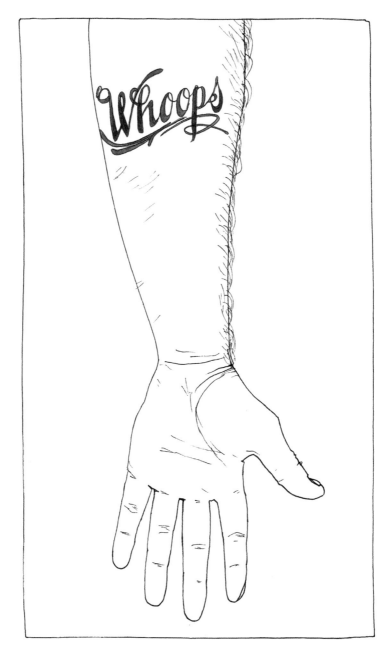

KYLE KINANE, COMEDIAN

I GOT THIS WITHOUT MUCH THOUGHT, LIKE MOST of MY TATTOOS. THE ONES I THOUGHT WERE COOL WHEN I WAS 18 I HATED WHEN I WAS 25, and THE ONES I GOT WHEN I WAS 25 I HATED WHEN I WAS 30. THEY GET OLD QUICK. MY LEG TATTOO of A COMPASS ROSE SAYS, "LOLLAPALOOZA '95." FLYING CLOCK on MY SHOULDER COULD READ "REALLY into COMMUNITY COLLEGE PHILOSOPHY COURSES." GETTING "WHOOPS" on MY ARM SEEMED LIKE AN APPROPRIATE RESPONSE to ALL THESE PERMANENT BUMPER STICKERS I KEEP SLAPPING on THIS AGING JALOPY. PLUS IT'S WORTH A LAUGH at THE BAR.

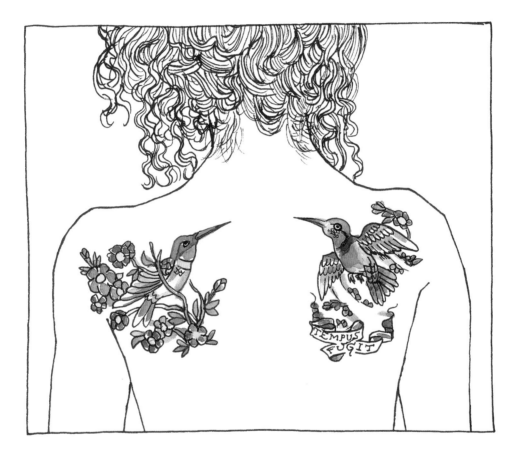

CASSY FRITZEN, BARTENDER

I HAD NEVER BEEN INTERESTED in GETTING A TATTOO UNTIL AFTER MY FIANCÉ, STEVE, DIED from CANCER. HE HAD SO MANY HIMSELF, and I WANTED to MEMORIALIZE HIM. LATE into HIS DISEASE STEVE WAS BOUND to OUR HOME, WHICH FORTUITOUSLY LOOKED OUT UPON A MEADOW. I SET UP HUMMINGBIRD FEEDERS ALL OVER SO HE COULD LAY ON OUR COUCH or SIT by THE SLIDING-GLASS DOOR and WATCH THE SMALL BIRDS. WE ALWAYS GOT EXCITED WHEN ONE WOULD COME DRINK THE SWEET SYRUP I MADE RELIGIOUSLY to FILL THE FEEDERS. "HUMMINGBIRD," STEVE WOULD CALL OUT to ME WHENEVER HE SAW ONE.

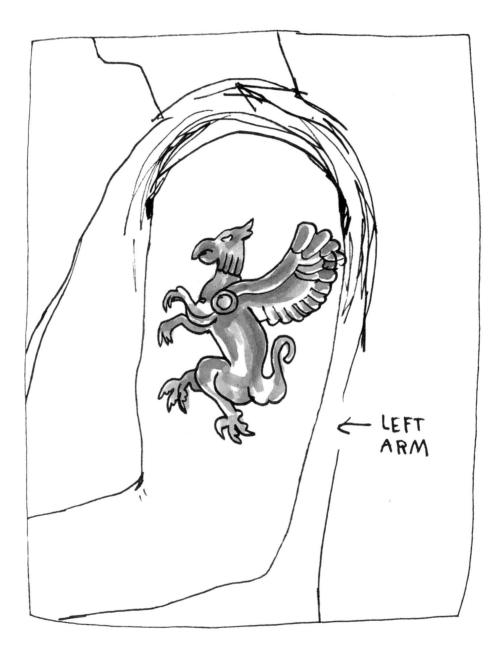

← LEFT ARM

14

EVAN JONES, LAW SCHOOL STUDENT

I GOT THIS TATTOO WHEN I WAS EIGHTEEN.
MY FRIENDS HAD INK SKULLS in ARMY HELMETS
n LOONEY TOONS GANGSTERS in BLUE ZOOT SUITS
HOLDING TOMMY GUNS. I WANTED MY TATTOO to
SAY SOMETHING ABOUT ME. TO REMIND ME WHO
I AM. SO I CHOSE THE GRIFFIN. BEING MIXED, I HAVE
A LOT of FEELINGS ABOUT AMERICA and WHERE WE
as A SOCIETY SHOULD BE on RACE. AS MUCH AS I
LOVE THIS COUNTRY and ITS SYMBOLISM I HAVE NOT
ALWAYS FELT IT COMPLETELY REPRESENTED ME... OR WAS
MEANT to. THE GRIFFIN HAS A HEAD of AN EAGLE (AMERICA)
and THE BODY of A LION (REPRESENTING MY AFRICAN ANCESTRY).
THAT REALLY SPOKE to ME. THE MELDED IDENTITIES.
I LIKED THAT IT WAS TWO THINGS at ONCE and I
DIDN'T HAVE to CHOOSE A SIDE.

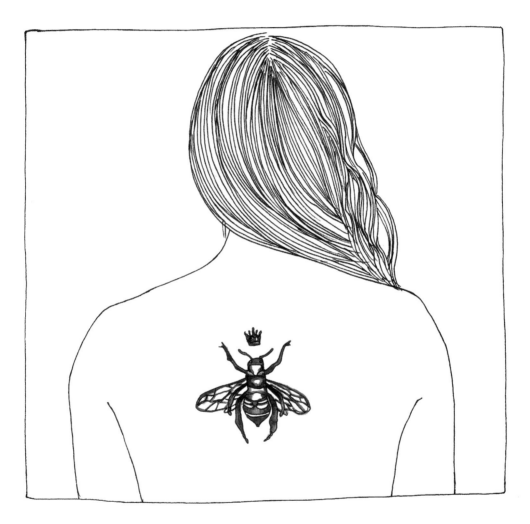

CHRISTINE HOSTETLER, COPYWRITER

WHEN WE WERE LITTLE, MY SISTER and I WOULD RACE AFTER BEES in THE LAVENDER BUSHES and TRY to PET THEM WITHOUT GETTING STUNG. WE WERE in AWE of THEIR TINY STINGERS THAT COULD BRING A GROWN MAN DOWN.

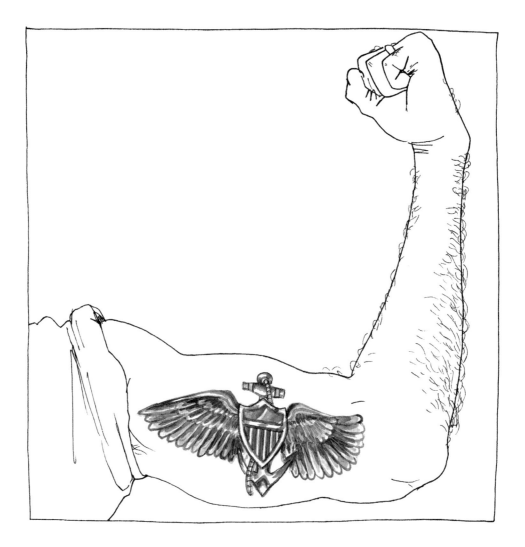

NICK TURNER, LIEUTENANT in THE U.S. NAVY

AS A SEASONED NAVY MAN and A STUDENT of HISTORY,
I FEEL A STRONG PULL to THE SAILORS of MY GRANDFATHER'S
GENERATION. WWII MEN WITH ROLLED-UP SLEEVES, LUCKY
STRIKES, A COCKED HAT, and A FOREARM ANCHOR TATTOO.
AS A NOD to MY OWN AVIATION TRAINING, I ADDED THE
GOLD PILOT WINGS and GOT PERMANENTLY MARKED in
THE STYLE of SAILOR JERRY.

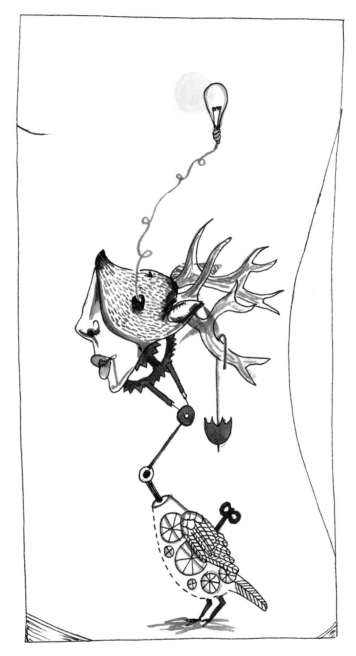

MORGAN ENGLISH, RESEARCH DIRECTOR

MY GRANDMA DIED in A FREAK ACCIDENT in MAY of LAST YEAR. SHE WAS HEALTHY as AN OX - TRAVELING THE WORLD WITH HER BOYFRIEND WELL into HER 80s - THEN SHE BROKE HER FOOT, WHICH CREATED A BLOOD CLOT THAT TRAVELED to HER BRAIN. THREE DAYS LATER, SHE WAS GONE.

THE RESPECT and ADMIRATION I HAVE for HER IS DIFFICULT to ARTICULATE. HERE WAS A WOMAN WHO ENDURED TWO DEPRESSIONS (POST-WWI WEIMAR GERMANY, from WHICH SHE ESCAPED to THE U.S. in 1929, JUST BEFORE OUR STOCK MARKET CRASHED) FOLLOWED by A SERIES of TRAUMATIC EVENTS (INCESTUOUS RAPE, A VIOLENT HUSBAND, THE SUICIDE of HER ONLY SON). YOU'D THINK THESE THINGS WOULD BREAK A PERSON, OR AT LEAST HARDEN THEM, BUT SHE ONLY GREW MORE FOCUSED. SHE ONCE TOLD ME, "FIX YOUR EYES on THE SOLUTION, IT'S THE ONLY WAY THINGS GET SOLVED! JUST KEEP MOVING and YOU'LL BECOME THE WOMAN YOU'VE ALWAYS WANTED to BE."

MY TATTOO IS A SERIES of CHILDHOOD MOMENTS COMBINED to EMBODY HER SPIRIT in AN ABSTRACT WAY. THE BUCK HEAD COMES from THE WILD DEER THAT LIVE in THE WOODS NEAR HER HOME. THE GEARS and LIGHTBULB COME from OUR FAVORITE EPISODE of THE SIMPSONS, WHERE LISA INVENTS A PERPETUAL MOTION MACHINE. THESE BITS and PIECES of MEMORIES MAKE UP MY SURREAL TRAVELING COMPANION, A FOREST CREATURE - PERPETUAL MOTION MACHINE. A HYBRID of ORGANIC and MECHANICAL RAW POWER, GENTLY RESTING ITS HEAD on MY HIP AS IF to ASK, "WHERE WILL WE GO TODAY?"

MORE ON OTHER SIDE OF ARMS as WELL

ROXANE GAY, WRITER and PROFESSOR

I HARDLY REMEMBER NOT HATING MY BODY. I
GOT MOST of MY SEVEN ARM TATTOOS WHEN I
WAS NINETEEN. I WANTED to BE ABLE to LOOK
at MY BODY and SEE SOMETHING I DIDN'T LOATHE,
THAT WAS PART of MY BODY by MY CHOOSING
ENTIRELY. REALLY, THAT'S ALL I EVER WANTED.

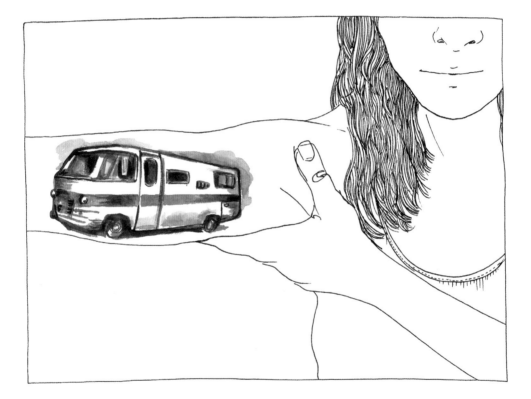

ANDREA de FRANCISCO, CAFE OWNER

EDWINA IS NOT JUST AN RV- SHE'S A PEA GREEN 1972 DODGE TRAVCO FULL of MEMORIES. SHE BELONGED to MY AUNT, UNCLE, and TWO COUSINS, SAM and NICA. TOGETHER THEY EXPLORED THE COUNTRY EVERY CHANCE THEY GOT. FROM THE GRAND CANYON to DEATH VALLEY, EVEN into CANADA. IT WAS in CANADA on JULY 22, 2011, THAT THEY WERE HIT by AN ONCOMING SEMI-TRAILER TRUCK THAT LOST CONTROL. A FOURTH of MY FAMILY WAS GONE. SAM WAS ELEVEN. NICA WAS NINE. MY TATTOO of EDWINA IS NOT ONLY A TRIBUTE to MY FAMILY'S MEMORY and SPIRIT, BUT ALSO A REMINDER to LIVE in THE MOMENT, EXPLORE, and ENJOY EVERY DAY.

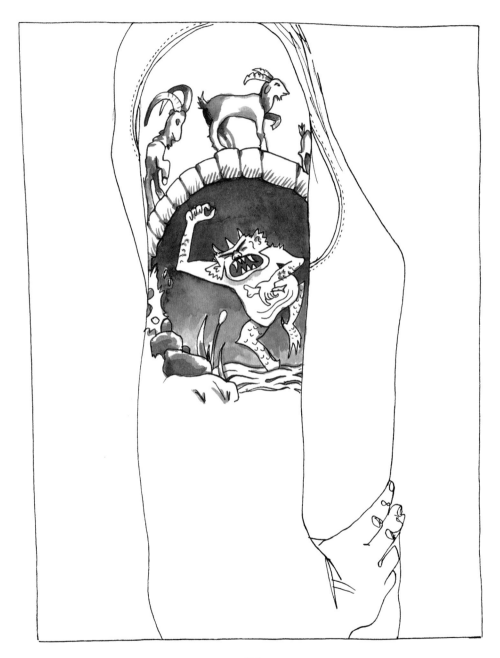

EMILY CABLE, LIBRARIAN

"TRIP TRAP, TRIP TRAP." THE SOUND of THE THREE
BILLY GOATS GRUFF CROSSING THE BRIDGE WAS THE
SAME in NORWEGIAN AS IT WAS in ENGLISH, and
THUS IT WAS THE ONLY PART of THE FOLK TALE THAT
I UNDERSTOOD WHEN MY GRANDPA TOLD IT to ME
in HIS PARENTS' NATIVE TONGUE. TIME and TIME
AGAIN, HIS WORDS ALWAYS WITHOUT MEANING,
SAVE "TRIP TRAP, TRIP TRAP."

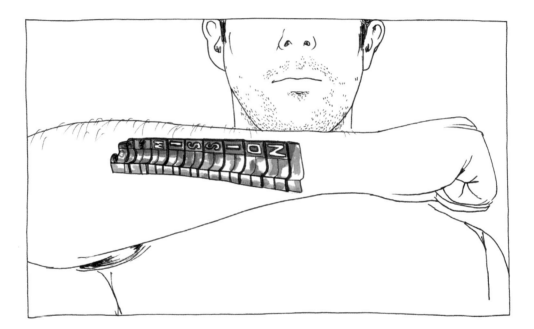

28

JOSHUA MOHR, WRITER

I GET A TATTOO COMMEMORATING EVERY NOVEL I WRITE. THE ONE THAT MEANS THE MOST to ME IS A PICTURE of THE NEW MISSION MARQUEE, WHICH IS AN OLD, DILAPIDATED THEATER on MISSION STREET. WE USED IT for THE COVER of MY BOOK DAMASCUS. IT'S MORE THAN JUST A COMPELLING IMAGE, THOUGH. IT'S MY LOVE LETTER to SAN FRANCISCO, MY HOME SINCE I WAS SEVENTEEN. IT'S ALSO A TRIBUTE to GETTING SOBER. A LOT of MISSION DISTRICT ARTISTS FALL into THAT AGE-OLD TRAP, DRINKING and DRUGGING SO HARD THAT YOU FORGET THE WORLD IS in COLOR. ANYWAY, I WAS WRITING DAMASCUS and SUDDENLY AN OPTIMISM THAT WASN'T in MY FIRST TWO BOOKS STARTED to CREEP in. MY WORLDVIEW WAS MORPHING, EVOLVING. THE TATTOO REMINDS ME of EMERGING from THAT HIBERNATION, LOOKING AROUND, and LOVING THIS MAGICAL CITY.

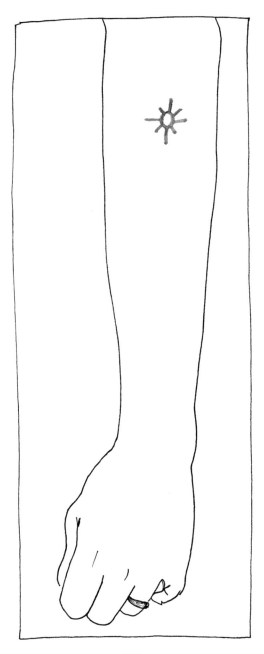

CARSON ELLIS, ILLUSTRATOR

I MADE THE SMALL SUN-SHAPED TATTOO MYSELF WITH A SEWING NEEDLE and INDIA INK WHEN I WAS SIXTEEN. IT WAS SOMEONE ELSE'S IDEA — A GUY I WAS in LOVE WITH in HIGH SCHOOL. WE BROUGHT THE NEEDLES from HOME, STOLE THE INK from A SUPPLY CLOSET at SCHOOL, and SAT in THE ART ROOM DURING LUNCH... POKE, POKE, POKING OUR ARMS OVER and OVER AGAIN, OCCASIONALLY STOPPING to RE-STERILIZE THE NEEDLE by HOLDING IT OVER A SPARKED LIGHTER. THE GUY GOT BORED QUICKLY and ABANDONED HIS TATTOO — A FLYSPECK-SIZED CIRCLE WITH A HALF OVAL on EITHER SIDE THAT LOOKED LIKE SATURN, or MAYBE A TINY WATCH. IT'S FUNNY to THINK THAT HE STILL HAS THAT WEIRD LITTLE TATTOO, WHEREVER HE IS.

I, on THE OTHER HAND, WORKED and WORKED on MINE UNTIL IT WAS FINISHED.

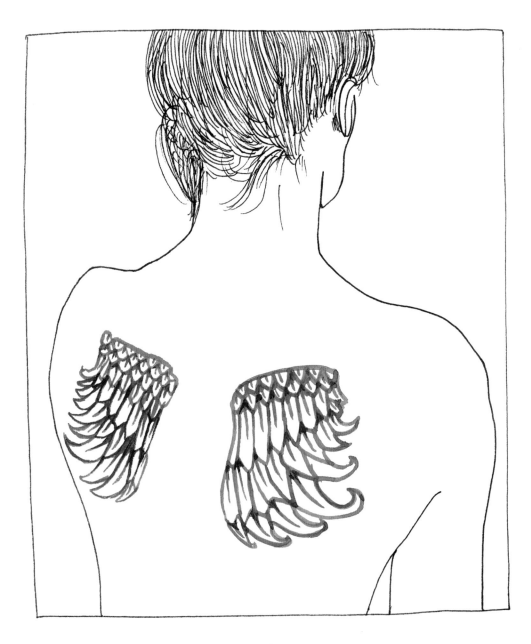

KIRSTY LOGAN, EDITOR

I GOT MY WINGS at THE AGE of EIGHTEEN, in THOSE DRIFTING MONTHS BETWEEN FINISHING SCHOOL and STARTING UNIVERSITY. THEY SYMBOLIZED MY FREEDOM, MY PLANS to ESCAPE THE RAIN and BOOZE and GRAY of SCOTLAND, to BURST into THE GLORY THAT I WAS SURE COULD BE FOUND ACROSS THE SEA. THE TATTOO IS JUST AN OUTLINE; I MEANT to GO BACK and GET THEM FILLED IN, BUT SOMEHOW A DECADE SLIPPED PAST. NOW I'M TWENTY-EIGHT and STILL in SCOTLAND and MY WINGS ARE UNSHADED. I LIKE THEM THIS WAY. UNFINISHED. LIKE MY PLANS for ESCAPE.

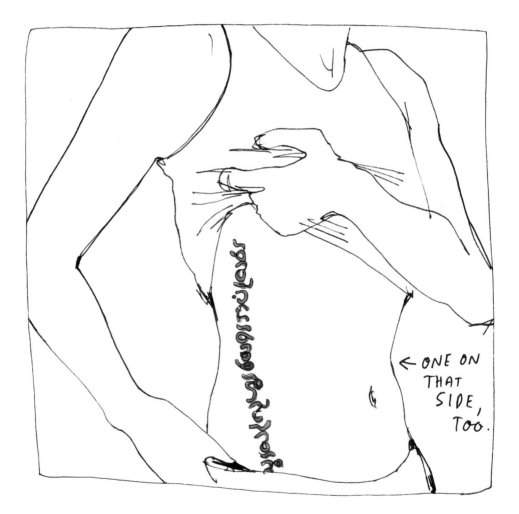

MAC McCLELLAND, JOURNALIST

THE FIRST TENET of THE KAREN REVOLUTION for INDEPENDENCE from THE BURMESE JUNTA IS "FOR US to SURRENDER IS OUT of THE QUESTION." LITTLE KIDS WEAR T-SHIRTS EMBLAZONED WITH IT; ADULTS BRING It UP, DRUNK and PATRIOTIC at PARTIES. AFTER I CAME HOME from LIVING WITH KAREN REFUGEES on THE THAI/BURMA BORDER in 2006, and BEFORE I WROTE A BOOK of THE SAME TITLE, I GOT THE FIRST TENET and THE FOURTH – "WE MUST DECIDE OUR OWN POLITICAL DESTINY" – TATTOOED on EACH SIDE of MY RIBCAGE SO I WOULDN'T EVER FORGET WHAT SOME PEOPLE WERE FIGHTING FOR. WHICH, THOUGH A LITTLE DRAMATIC, IS BY FAR THE BEST CAUSE ANY of MY TATTOOS CAN CLAIM.

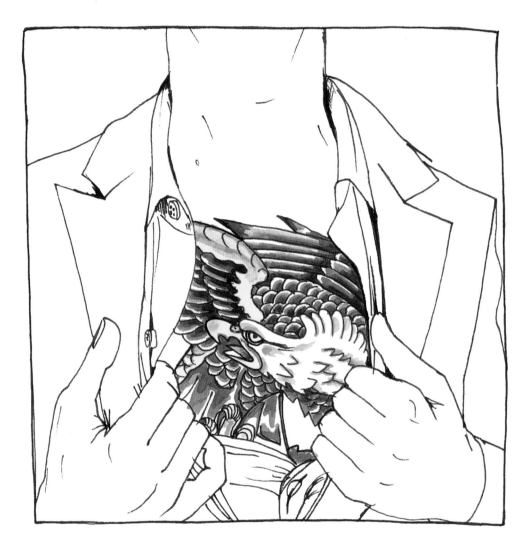

RYAN M. BESHEL, PUBLIC RELATIONS COORDINATOR

MY POPS and I HAVE STARTED to GET CLOSE THESE PAST FEW YEARS. WE'RE GETTING to KNOW EACH OTHER as PEOPLE MORE and MORE EVERY DAY. MY EAGLE IS in HONOR of HIM, and EVERYTHING HE'S DONE — and CONTINUES to DO — to OFFER HIS SUPPORT to MY BROTHER, MY SISTERS, and MYSELF. HE IS A HUGE HARLEY FAN. A BADASS. I WANTED A TATTOO THAT WAS THE SAME.

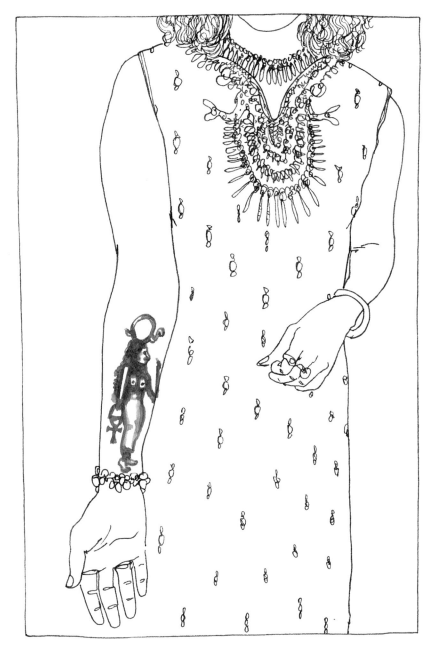

MONA ELTAHAWY, WRITER and PUBLIC SPEAKER

I LOST SOMETHING THE NIGHT THE EGYPTIAN RIOT POLICE BEAT ME and SEXUALLY ASSAULTED ME. I WAS DETAINED for SIX HOURS at THE INTERIOR MINISTRY and ANOTHER SIX by MILITARY INTELLIGENCE, WHERE I WAS INTERROGATED WHILE I WAS BLINDFOLDED. DURING MY TIME at THE INTERIOR MINISTRY I'D BEEN ABLE to SURREPTITIOUSLY USE AN ACTIVIST'S SMART PHONE to TWEET "BEATEN, ARRESTED, INTERIOR MINISTRY." ABOUT A MINUTE LATER THE PHONE'S BATTERY DIED. I WON'T ALLOW MYSELF to IMAGINE WHAT COULD HAVE HAPPENED IF I HADN'T BEEN ABLE to SEND OUT THAT TWEET. AFTER I WAS FINALLY RELEASED, I FOUND OUT THAT WITHIN FIFTEEN MINUTES of THE TWEET #FREEMONA WAS TRENDING GLOBALLY, AL JAZEERA and THE GUARDIAN REPORTED MY DETENTION, and THE STATE DEPARTMENT TWEETED ME BACK to TELL ME THEY WERE on THE CASE. I KNEW I WAS LUCKY. IF IT WASN'T for MY NAME, MY FAME, MY TWEET, MY DOUBLE CITIZENSHIP, and SO MANY OTHER PRIVLEGES I MIGHT BE DEAD.

SEKHMET. THE GODDESS of RETRIBUTION and SEX. THE HEAD of A LIONESS. TITS and HIPS. THE KEY of LIFE in ONE HAND, THE STAFF of POWER in THE OTHER. THAT PARADOXICAL—OR PERHAPS THEY'RE TWO SIDES of ONE COIN—MIX of PAIN and PLEASURE. RETRIBUTION and SEX. I'D NEVER WANTED A TATTOO BEFORE, BUT AS SADNESS WASHED AWAY and MY ANGER and THE VICODIN WORE OFF, IT BECAME IMPORTANT to BOTH CELEBRATE MY SURVIVAL and MAKE A MARK on MY BODY of MY OWN CHOOSING.

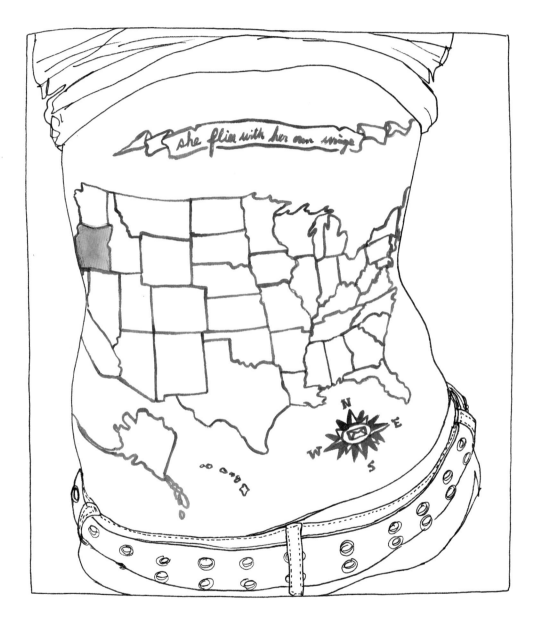

KRISTE YORK, MASTER'S DEGREE STUDENT

I MARKED MY 40th BIRTHDAY WITH THIS TATTOO, THUS BECOMING A HUMAN RV. ONCE A YEAR I'LL FILL in THE STATES I'VE VISITED SINCE MY LAST BIRTHDAY, WITH THE GOAL of COLORING THEM ALL in BEFORE I TURN FIFTY in 2023. I LIVE in OREGON and THE WORDS in THE BANNER ARE OUR STATE MOTTO: "SHE FLIES WITH HER OWN WINGS."

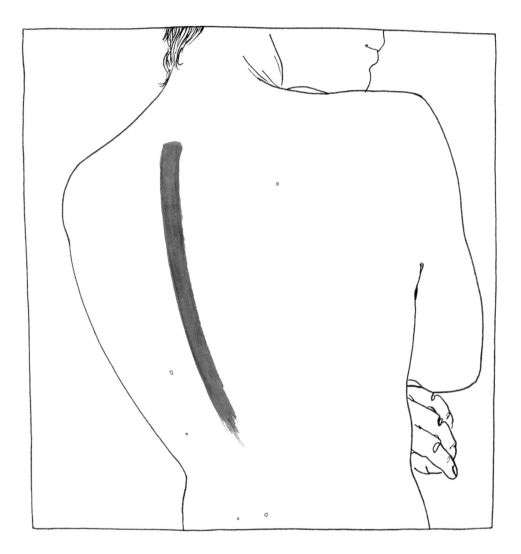

JIZ LEE, GENDERQUEER PORNSTAR

IT'S MY ONLY.

A GRAY-BLUE STRIPE DOWN MY SPINE, JUST BETWEEN THE SHOULDER BLADES, RESEMBLING A BRUSH STROKE. IF YOU LOOK CLOSELY, THERE ARE DARKER LINES WITHIN THE DOWNWARD SWIPE, STREAKS WILL STAND OUT MORE AS THE TATTOO AGES. KIND OF LIKE PAINT FADING ON WOOD.

THE LINE SYMBOLIZES "BALANCE," ILLUSTRATING A VERTICAL AXIS. AT THE TIME I GOT IT, MY LIFE WAS FOCUSED ON DANCING AND SWIMMING, SO BALANCE MEANT WORKING ON VERTICAL ROTATION, LIKE EXECUTING A TRIPLE PIROUETTE. BUT ONE COULD EASILY EXTEND THE METAPHOR AS I WAS ALSO TRYING TO FIND BALANCE IN OTHER ASPECTS OF MY YOUNGER LIFE: RELATIONSHIPS, WORK, RECREATIONAL DRUG USE, SEX, AND SELF-CONTROL. EVEN STANDING IN PLACE IS ALL ABOUT FINDING BALANCE, AND THE SIMPLE ACT OF WALKING IS ABOUT UP-RIGHTING A SUCCESSION OF FALLS.

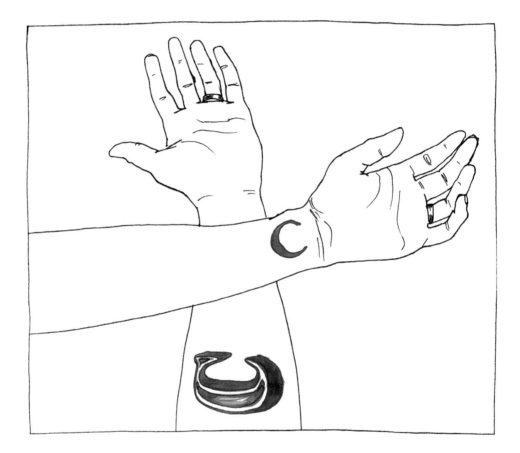

ALEXIS C. MADRIGAL, WRITER, and
SARAH C. RICH, WRITER

AFTER WE DECIDED to GET MARRIED, ONE of THE CHALLENGES WE FACED WAS WHAT to DO WITH OUR NAMES. FOR A WRITER, CHANGING YOUR NAME MEANS CHANGING YOUR BYLINE, SOMETHING YOU'VE WORKED YOUR WHOLE CAREER to BUILD. WE WERE HESITANT.

SO WE FOUND A MIDDLE GROUND WITH OUR MIDDLE NAMES, BOTH of WHICH BEGIN WITH C, and BOTH of WHICH NEITHER of US IS VERY FOND of. NOW WE HAVE A SHARED MIDDLE NAME, ONE THAT ONLY WE KNOW. ALEXIS C. MADRIGAL and SARAH C. RICH. THE SYMBOL of OUR INDEPENDENT UNION TATTOOED on OUR FOREARMS.

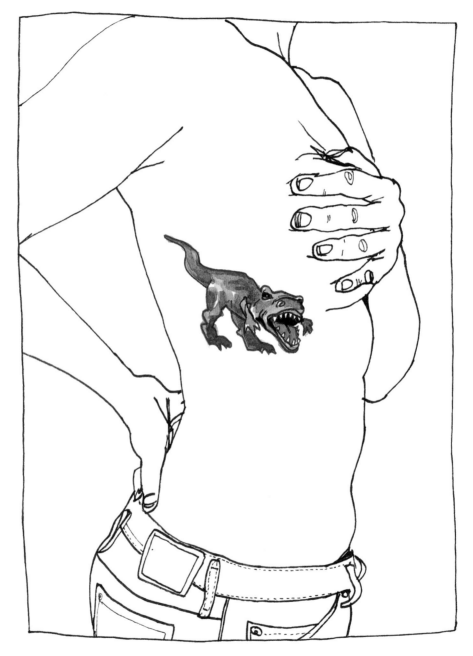

ALISE ALICARDI, BETWEEN JOBS

I'D WANTED A TATTOO for AS LONG AS I CAN REMEMBER, BUT COULD NEVER DECIDE on WHAT. "THINK ABOUT IT for AT LEAST A YEAR," EVERYONE SAID. "BE SURE," THEY SAID. "BUT WHAT ABOUT YOUR WEDDING DAY?"- MY MOTHER. "BUT WHAT ABOUT WHEN YOU'RE SEVENTY?"- MY FATHER.

A YEAR AGO, WHILE EATING A CHEESE SANDWICH, I THOUGHT, "I'M EITHER GOING to DIE WISHING I'D GOT A TATTOO or WISHING I HADN'T. IT'S 50/50." ON THE WAY to THE SHOP - WITHOUT AN APPOINTMENT OR A PLAN - I DECIDED ON A T-REX. THIS MAY OR MAY NOT HAVE SOMETHING to DO WITH MY PAIN- FULLY SMALL HANDS. AND NOW, EVERYWHERE I GO, MY T-REX REMINDS ME NOT to TAKE MYSELF too SERIOUSLY. AFTER ALL, I HAVE A DINOSAUR on MY RIBS.

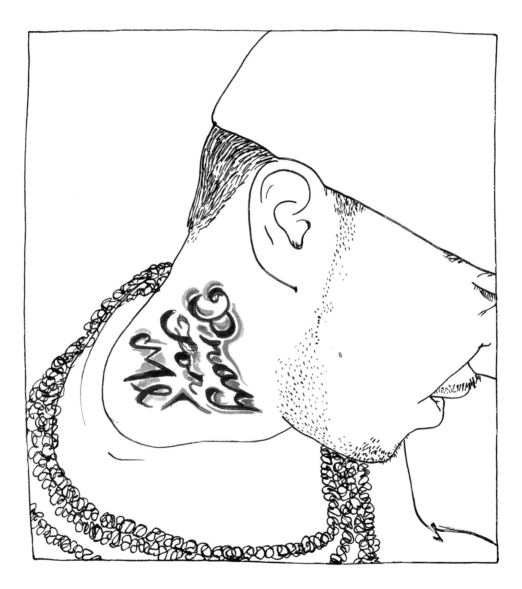

FRENCH MONTANA, RAPPER

I DECIDED to GET MY TATTOO AFTER I SURVIVED BEING SHOT in THE BACK of THE HEAD. I REALIZED I HAD MADE IT THROUGH SOMETHING, SO I DECIDED to GET "PRAY for ME." I'M AN ANOMALY BECAUSE MUSLIMS AREN'T SUPPOSED to GET TATTOOS, BUT I WANTED THOSE PRAYERS and BLESSINGS. I WANTED PEOPLE to PRAY for ME.

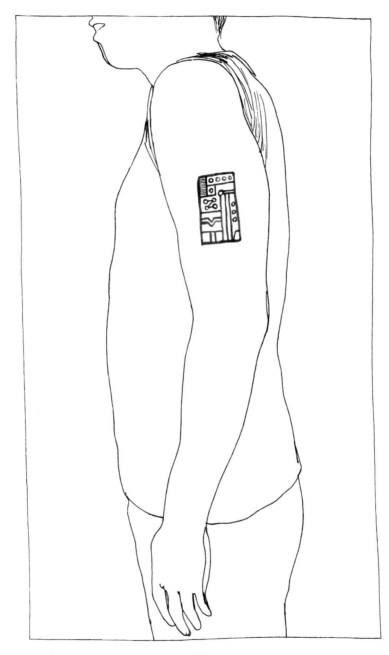

50

ANTHONY HA, TECH BLOGGER

WHEN I TRY to EXPLAIN THE TATTOO, I USUALLY FUMBLE AROUND SAYING THAT THE MOTHER BOX COMES from THE FOURTH WORLD COMICS by JACK KIRBY: "YOU SEE, MISTER MIRACLE IS THE ULTIMATE ESCAPE ARTIST, and THIS ALIEN COMPUTER CALLED THE MOTHER BOX HELPS HIM GET OUT of ANY TRAP, and... and..." BUT REALLY, I JUST WANTED SOMETHING, ANYTHING by KIRBY. IN ADDITION to BEING THE BEST SUPER-HERO ARTIST EVER, I LOVE HIM for TELLING UNDENIABLY PERSONAL, DISTINCTIVE STORIES at DC and MARVEL, THE IP FACTORIES THAT HAVE COLONIZED OUR DREAMS (or AT LEAST MINE). YOU CAN USUALLY RECOGNIZE A KIRBY IMAGE INSTANTLY, and WHEN WE LINE UP to WATCH THOR or THE AVENGERS, WE'RE REALLY PAYING to SEE THE SHADOWS of HIS BEST WORK.

SO YES, THE TATTOO COULD HAVE BEEN GALACTUS, or THE RAINBOW BRIDGE of ASGARD, or THE CLIMACTIC PANEL from THE GLORY BOAT. THE MOTHER BOX IS WHAT FIT. IT'S WEIRD and BEAUTIFUL and REPRESENTATIVE of INDIVIDUAL IMAGINATION. SOMEONE PUT IT THIS WAY AFTER ONE of MY FUMBLING ATTEMPTS at AN EXPLANATION: "I LOVE IT. IT'S PERSONAL MYTHOLOGY." YES, EXACTLY.

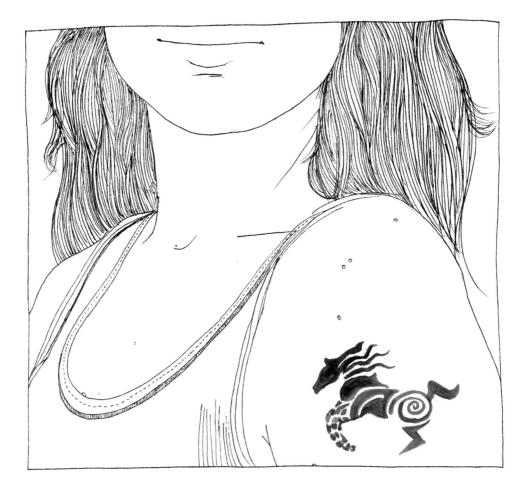

CHERYL STRAYED, WRITER

I GOT MARRIED CRAZY YOUNG to A MAN I WAS CRAZY in LOVE WITH, BUT from THE FIRST MOMENT of OUR MARRIAGE I KNEW I'D MADE A MISTAKE. NOT in LOVING HIM, BUT in MARRYING HIM. I WASN'T YET TWENTY and I WAS SOMEONE'S WIFE. WHO'D I GO and DO THAT?

OUR DECISION to DIVORCE SIX YEARS LATER WAS EXCRUCIATINGLY PAINFUL. WE LOVED EACH OTHER, EVEN THOUGH WE COULDN'T BE A COUPLE ANYMORE. WE'D LEARNED So MUCH from OUR TIME TOGETHER and WE HATED THAT OUR DIVORCE SEEMED to OBLITERATE THAT, HATED HOW IT COMMUNICATED to THE WORLD THAT OUR SEPARATENESS WAS MORE PROFOUND THAN OUR CONNECTEDNESS. IT WAS THE OPPOSITE of TRUE. SO WE CAME UP WITH AN IDEA to HONOR THE FACT THAT WE'D FOREVER BE MARKED by EACH OTHER.

WHEN WE EXPLAINED IT to THE TATTOO ARTIST in A TINY SHOP in MINNEAPOLIS, SHE HESITATED. SHE HAD A POLICY ABOUT COUPLES. SHE REFUSED to DO MATCHING TATTOOS for THEM BECAUSE THEY'D INEVITABLY BREAK UP and REGRET THE TATTOO and THEN SHE'D BE PART of SOMETHING UGLY. BUT SHE'D NEVER HEARD of A COUPLE WANTING A DIVORCE TATTOO, and SHE WAS MOVED by THE IDEA. PLUS, SHE COULDN'T FUCK US UP. WE'D ALREADY DONE THAT OURSELVES.

I HELD HIS HAND and HE HELD MINE AS, ONE AFTER THE OTHER, THE NEEDLE PUSHED THE BLUE INK into OUR LEFT DELTOIDS. "DOES IT HURT?" WE ASKED EACH OTHER, BUT WE ALREADY KNEW: NOT HALF AS MUCH AS DIVORCE.

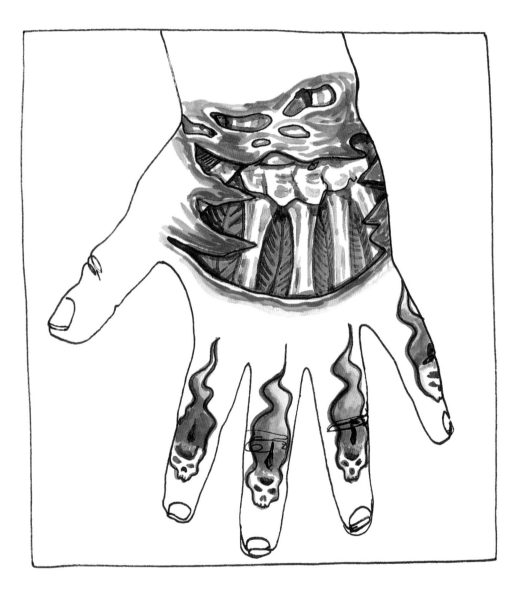

JEREMY SPENCER, DRUMMER

I GOT MY HAND SKELETON DURING MY
PARTYING DAYS. I REMEMBER WAKING UP THE
NEXT MORNING, LOOKING at IT, and THINKING,
"WHAT DID I DO?" OUR GUITAR PLAYER, JASON
HOOK, HAD PASSED OUT at MY PLACE THAT
NIGHT, and WHEN HE STAGGERED DOWN THE
STAIRS I SAW HE HAD HIS THROAT NEWLY
TATTOOED, too.

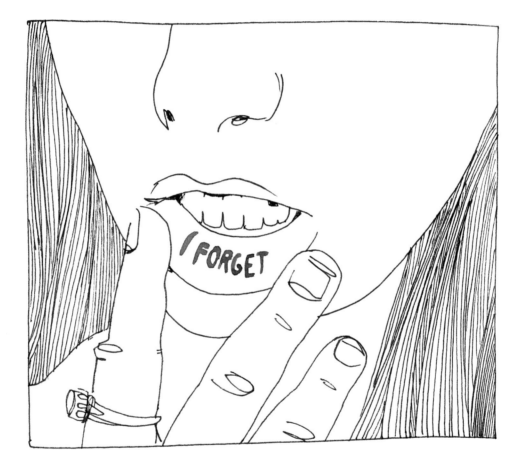

YURI ALLISON, STUDENT

I HAVE AN EPISODIC MEMORY DISORDER. I DON'T
HAVE ANY LONG-TERM MEMORY. MY CHILDHOOD IS
COMPLETELY BLANK, AS IS MY SCHOOLING UNTIL
HIGH SCHOOL. TECHNICALLY I CAN'T RECALL ANYTHING
THAT'S BEYOND THREE YEARS in THE PAST. I FIND
IT VERY DIFFICULT to TALK ABOUT, SIMPLY BECAUSE
I STILL CAN'T WRAP MY HEAD AROUND THE IDEA
MYSELF, SO WHEN SOMEONE TALKS to ME ABOUT
A MEMORY WE ARE SUPPOSED to SHARE I SIMPLY
SMILE and SAY THAT I DON'T REMEMBER. JUST
LIKE MY MEMORIES, LIP TATTOOS ARE KNOWN to
FADE WITH TIME.

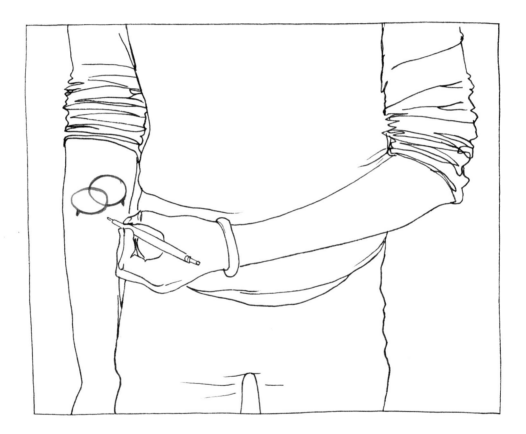

SUSIE CAGLE, COMICS JOURNALIST

I WAS in A RELATIONSHIP THAT DISSOLVED in LARGE PART BECAUSE of MY DEDICATION to MY WORK... and NOT-SO-SMALL PART BECAUSE of MY SHITTINESS at RELATIONSHIPS. I WANTED SOMETHING THAT WOULD REMIND ME of BOTH, SO I SETTLED on INTERCONNECTED SPEECH BALLOONS — A KIND of REMINDER to CONTINUE WORKING TOWARDS BEING A BETTER COMMUNICATOR, PERSONALLY and IN MY COMICS. MY FRIENDS TOLD ME EVERYONE REGRETS BREAKUP TATTOOS, DON'T DO IT, WHAT A CLICHÉ, OH GOD! BUT IT'S A REMINDER for ME of WHAT I WANT OUT of MY LIFE. AND WHEN ALL ELSE FAILS, IT'S FUN to WRITE DIALOG in THEM.

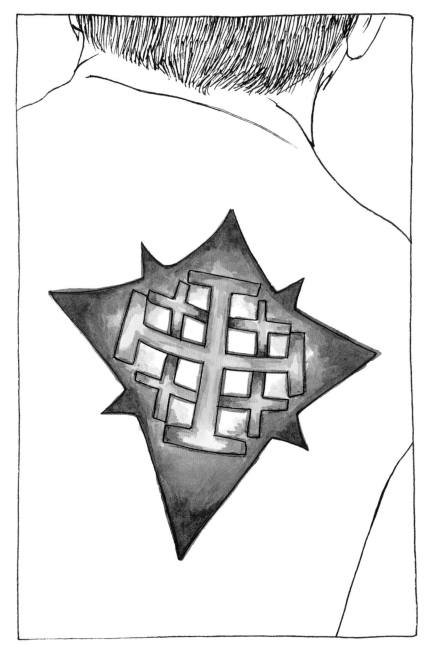

MJ CRAIG, ASSISTANT LAB MANAGER

MY TATTOO WAS STEP THREE in A FOUR-STEP
PROCESS of LEARNING to TRUST MYSELF and MAKE
INCREASINGLY PERMANENT DECISIONS WHILE
SIMULTANEOUSLY BREAKING BAD NEWS to MY MOTHER.
STEP 1. SHAVE LONG BLOND HAIR COMPLETELY OFF
TWO WEEKS AFTER MOVING AWAY from HOME. (MOTHER:
"BUT, WHY?") STEP 2. GET BRIDGE PIERCING. (MOTHER:
"DON'T YOU HAVE ENOUGH PAIN in YOUR LIFE ALREADY?") STEP 3.
GET A KAIROS CROSS INSIDE A COMPASS TATTOOED
on MY BACK. (MOTHER: "THAT'S VERY PERMANENT.")
STEP 4. TELL MOTHER THAT I AM TRANSSEXUAL.
(MOTHER: "BUT, WHY? DON'T YOU HAVE ENOUGH PAIN in YOUR
LIFE ALREADY? THAT'S VERY PERMANENT.")

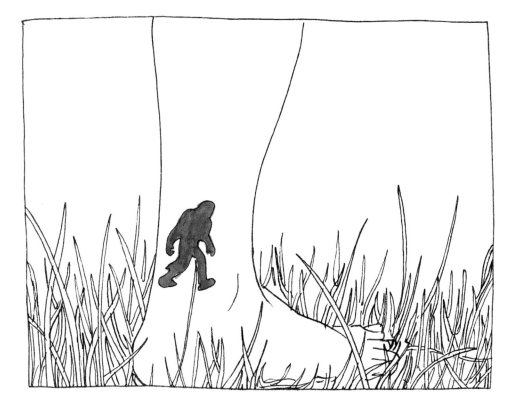

ERIN BECHTOL, INTERNATIONAL ESL TEACHER

I HADN'T TALKED to MY SISTER in YEARS. WE WERE STUBBORN and HURT, NEITHER ONE WILLING to ACCEPT HER ROLE in THE OTHER'S PAIN. ONE DAY SHE CALLED ME UP and I FINALLY ANSWERED. SHE WAS DEVASTATED - HAD BEEN LEFT by HER GIRLFRIEND, HAD NO PLACE to LIVE, ALMOST LOST HER JOB. I WAS PETRIFIED - LEAVING EVERYTHING and EVERYONE I KNEW to JOIN HER in A CITY 6,000 MILES AWAY. WE NEEDED EACH OTHER. SO WE OPENED A BOTTLE of GIN and FLED from OUR TROUBLES into THE MOUNTAIN RANGES and STRIP CLUBS, SEEKING COMFORT in FLESH and FOREST. COMMITTED to THE DENIAL of ALL THIS CHANGE, WE PURSUED PERMANENCE. I WANTED A WAY to KEEP THE FAMILY I HAD JUST GOTTEN BACK, and to RETAIN THE WILDNESS I HAD JUST DISCOVERED. NOW SASQUATCH WALKS with ME ALL AROUND THE WORLD on ADVENTURES EVERY BIT AS IMPROBABLE AS HE IS.

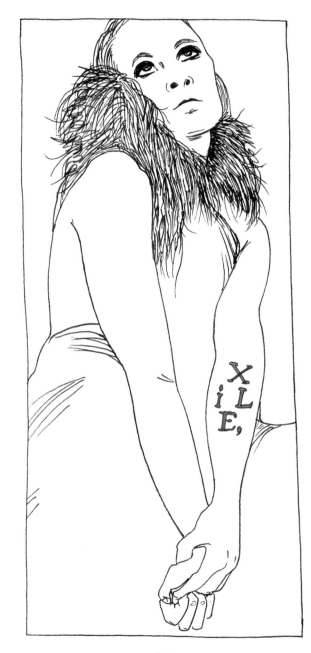

OTEP SHAMAYA of OTEP

I USED to BE PART of A GRAFFITI
CREW CALLED XILE9. THERE WERE
NINE of US, ALL FEMALE, BROUGHT
TOGETHER by A LOVE of TAGGING
and OUR STATUS AS OUTLAWS and
MISFITS DUE to OUR GENDER. WE
EARNED OUR RESPECT THROUGH
DEDICATION and TALENT - and BY
CRACKING A JAW n TWO ALONG THE WAY.

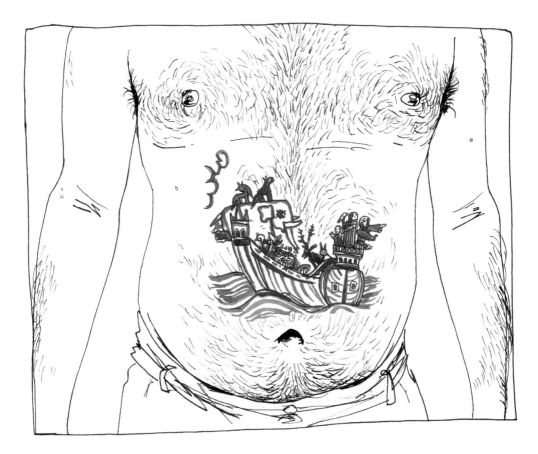

DMITRY SAMAROV, PAINTER, WRITER, FORMER CABDRIVER

I HAVE TEN TATTOOS. HALF of THEM ARE
BIBLE STORIES. I DON'T BELIEVE in ANY RELIGION,
BUT WE'VE BEEN TELLING EACH OTHER THESE
STORIES for SO LONG THAT THEY DON'T GO AWAY.
THERE'S THE BLIND LEADING THE BLIND, BIG FISH EATING
LITTLE FISH, THE TOWER of BABEL, and THIS ONE:
NOAH'S ARK. I DID THE DRAWING MYSELF, from
A WOOD CUT of A RUSSIAN FOLK ART TAPESTRY THAT
HUNG OVER MY BED WHEN I WAS A KID. I STILL HAVE IT
and IT STILL SPEAKS to ME. JUST DON'T ASK
EXACTLY WHAT IT'S SAYING...

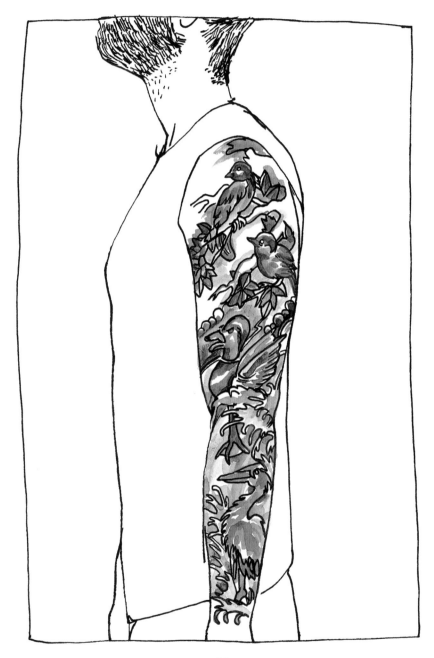

ERIC FLETCHER, PHOTOGRAPHER

THIS TATTOO IS THE STORY of MY TWO HOMES.
I WAS BORN IN TALLAHASSEE, FLORIDA, and ADOPTED
FOUR DAYS AFTER MY BIRTH. THREE YEARS LATER
MY FAMILY and I MOVED NORTH to MASSACHUSETTS.
I HAD NO MEMORY of OUR LIFE in THE SUNSHINE STATE,
NO CONNECTION TO THE PLACE. FAST FORWARD 25 YEARS.
I RECEIVE A LETTER STATING THAT MY BIRTH MOTHER
WOULD LIKE TO CONTACT ME. WE MEET, WE BECOME FRIENDS,
AND QUESTIONS THAT I'D HAD MY ENTIRE LIFE START to BE
ANSWERED. THE FIRST TIME WE MET IN FLORIDA WE
WENT KAYAKING on THE WAKULLA RIVER, WHOSE SHORES
WERE LINED WITH GREAT BLUE HERONS. WHEN I WAS
A CHILD IN MASSACHUSETTS, THE STREAM THAT RAN NEXT
TO OUR HOUSE HOSTED A FAMILY of MALLARD DUCKS EACH YEAR.
I PUT THESE BIRDS ALONG WITH OTHER SYMBOLS of
MY TWO HOME STATES (CHICKADEES and FALL FOLIAGE from MA.,
NORTHERN MOCKINGBIRDS and PALM TREES from FLORIDA) ON MY ARM,
WITH WATER, A CENTRAL THEME TO BOTH MY STORIES,
RUNNING THROUGHOUT. I'M NOT SURE IF ANY MEMBERS
of MY FAMILY, NORTH or SOUTH, ACTUALLY KNOW
WHAT THIS TATTOO MEANS. BUT I DO.

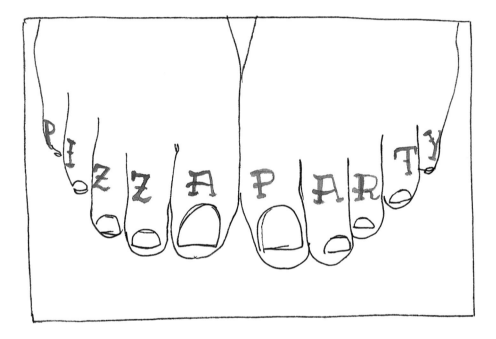

SIOBHAN BARRY, WAREHOUSE MANAGER

I REALLY FUCKING LOVE PIZZA.

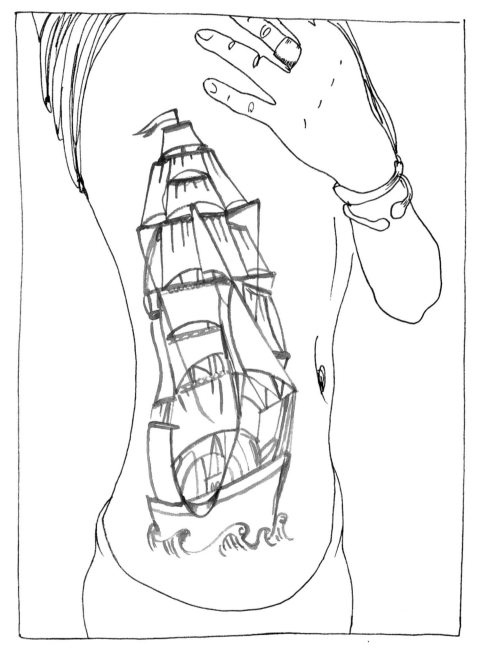

ALEXA SEUSS, GRAPHIC DESIGNER

I GOT THIS LINE DRAWING of A TALL SHIP WHEN I
WAS FRESHLY EIGHTEEN. IT'S A THREE MASTED BARKEN-
TINE TALL SHIP THAT ONCE WENT by THE NAME REGINA
MARIS. SHE WAS DOCKED in MY HOMETOWN PORT
on THE EASTERN TIP of LONG ISLAND for YEARS WHEN
I WAS YOUNG, MY PARENTS, ALONG WITH PEOPLE FROM
ALL WALKS of LIFE, ALL OVER THE COUNTRY, CAME
TOGETHER to RESTORE HER SO SHE COULD CONTINUE
SAILING. I SPENT MUCH of MY TIME on THAT SHIP
WHEN I WAS A BABY. HER BOW WAS MY PLAY AREA
and HER CREW WAS MY FAMILY. MY TATTOO IS A
REPRESENTATION of MY FAMILY, MY HOME ON THE
WATER, MY ETERNAL CONNECTION to THE SEA, and
THE FREEDOM THAT COMES WITH "GOING WITH THE
TRADE WINDS." IT'S ALSO in MEMORY of HER. SHE
WAS LATER SCUTTLED in THE BAY DUE to DETERIORATION.

73

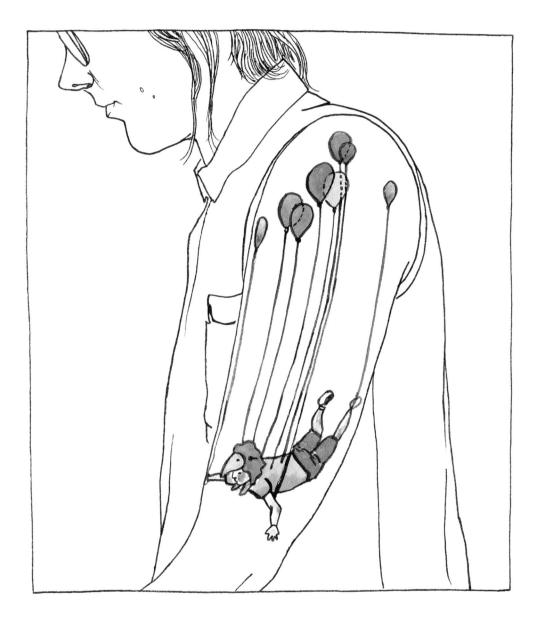

TIFFANY PARKER, FILM STREAMING
QUALITY CONTROL MANAGER

IN COLLEGE, MY BEST FRIEND and I WOULD PASS NOTES in OUR ART HISTORY CLASS. I'D WRITE ABOUT HOW BADLY I WANTED to GO to DISNEYLAND. HE'D DRAW PICTURES of BABY PYRAMIDS, ARABS on STILTS, DINOSAURS WEARING T-SHIRTS. HE DROPPED OUT and MOVED AWAY, and FOR A WHILE MY GUTS HURT. A COUPLE YEARS LATER I LOOKED THROUGH ALL OUR NOTES. ABRAHAM LINCOLN in A FLYING FLAG, A GIRAFFE LOOKING in THE MIRROR, KIDS CLIMBING LADDERS LEADING to NOWHERE, and THEN THIS. I GOT THE TATTOO and FELT BETTER.

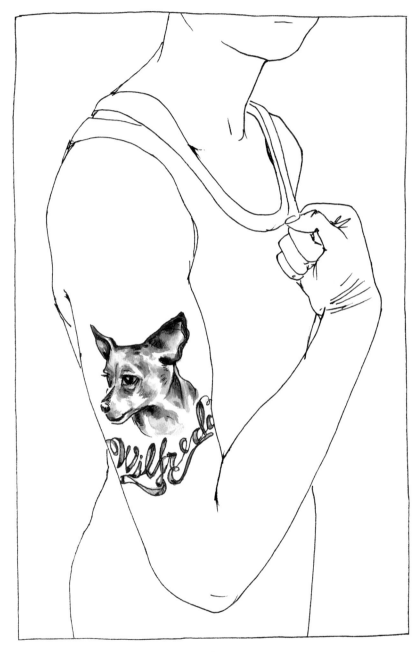

LISA CONGDON, ARTIST and ILLUSTRATOR

I MET WILFREDO THROUGH A DOG RESCUE in 2007.
HE WAS FIVE MONTHS OLD and CURLED UP in
SOMEONE'S LAP. WHEN THEY HANDED HIM to ME
I FELL INSTANTLY in LOVE. HE HAS GREEN EYES,
BEAUTIFUL FAWN COLORED FUR, and A PINK NOSE.
HE'S THE SWEETEST CHIHUAHUA I'VE EVER KNOWN.
HE'S THE SWEETEST DOG I'VE EVER KNOWN. I
LOVE HIM MORE THAN WORDS CAN SAY. IN 2010,
I DECIDED to GET A PORTRAIT of HIM TATTOOED
on MY ARM WITH HIS NAME WRITTEN in SCRIPT
BELOW. NOW HE'LL BE WITH ME FOREVER.

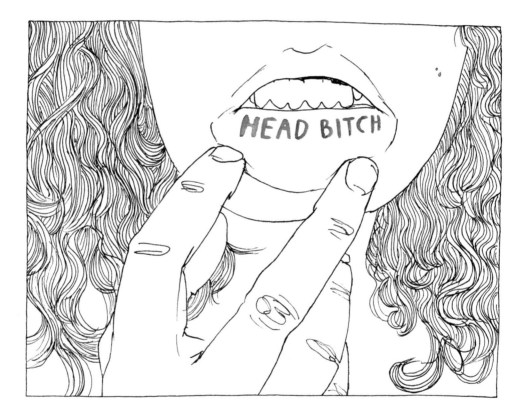

MELISSA CHADBURN, UNION ORGANIZER

BECAUSE ONCE WE WERE TWO. HE A TALL, DARK-SKINNED, MUSCLED BLACK GUY THAT HAD ALREADY APPEARED on L.A.'S MOST WANTED. A LOVER. A MISOGYNIST. A STEALTHY FIGHTER. I CAN STILL SEE HIM STRIPPED DOWN to HIS BOXERS HOPPING UP and DOWN. ELBOWS HIGH — HIS FEET SCISSORING BACK and FORTH, FIGHTING OFF GAGGLES of FRAT BOYS. THE HNIC : HEAD NIGGA in CHARGE. AND ME, HIS YOUNGER SISTER, LIGHTER : HBIC : HEAD BITCH in CHARGE. WE THRUST OUR THUMBS OUT on THE PACIFIC COAST HIGHWAY. TOOK US EVERYWHERE. EVENTUALLY I GOT FARTHER on MY OWN. ADOPTED, HIGH SCHOOL DIPLOMA, COLLEGE. LOVED vs. FEARED. I GOT too FAR, EVEN. HE DRIFTED TOWARDS THE LIGHT of FUCK IT, TOWARD THE LIGHT of LEAVING HIS BODY. NO MORE L.A.'S MOST WANTED.

NO MORE COUNTY FOOD, CLOTHES, CHECKS. NO MORE COUNTY ANYTHING. A NEEDLE in HIS VEIN and A GASH on HIS SKULL — BLOOD DRIPPING DOWN HIS FACE — TOOK HIM OUT...THERE WAS A LULL at WORK, A PIERCING and TATTOO STUDIO in THE CASTRO. I LAID on THE TABLE. FOLDED DOWN THE CORNERS of MY BOTTOM LIP, and LOOKED at THE CEILING AS THE WORDS WERE ETCHED IN FOREVER : "HEAD BITCH." I SWALLOW IT EVERY DAY. A BROTHER-SHAPED HOLE.

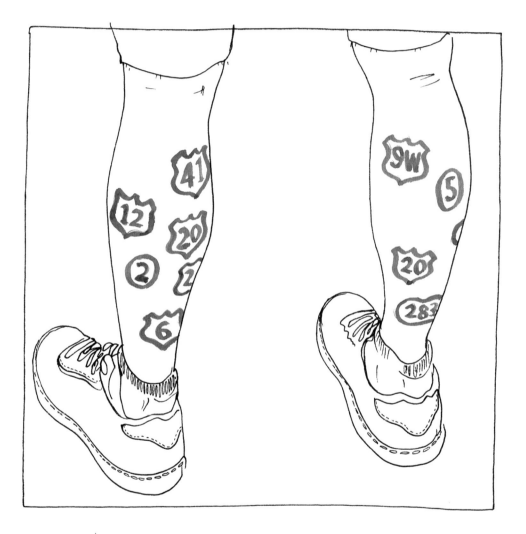

SCOTT KLOCKSIN, PEDICAB OPERATOR and JOURNALIST

I GET A STRIKINGLY PREDICTABLE SET of QUESTIONS from MY CUSTOMERS. THE FIRST IS USUALLY: "WHAT'S UP WITH THE INTERSTATES on YOUR LEGS?" IT'S THE ROUTE I TOOK WHEN I RODE MY BIKE from NEW YORK CITY to CHICAGO. "DAMN, HOW LONG DID THAT TAKE YOU?" 11 DAYS. "SO, DO YOU RACE BIKES?" USED to. "WHERE'D YOU SLEEP?" IN A CRAPPY ONE-PERSON TENT on THE SIDE of THE ROAD, in CAMPSITES at STATE PARKS, or IN CHEAP MOTEL ROOMS WHOSE PRICES I TALKED DOWN by TELLING THE FRONT DESK ATTENDANT HOW I GOT THERE. "ARE YOU CRAZY?" CLEARLY. I WRITE and RIDE A GIANT TRICYCLE for A LIVING.

82

SARAH NICOLE PRICKETT, WRITER

1. FIRST BOYFRIEND. FIRST, MY BEST FRIEND. EVERYTHING WAS NORMAL and NOTHING HURT.
2. AN ACCIDENT THAT, IF IT HAD HAPPENED to MY FRIEND, I'D HAVE CALLED IT RAPE.
3. SECOND BOYFRIEND. I WANT to NEVER REMEMBER HIM, WHICH ISN'T HARD.
4. TRUE PATRIOT SK8R BOI. GAVE ME CHLAMYDIA.
5. BASSIST in A BAND YOU'VE NEVER HEARD of.
6. G-MONEY for LIFE. A FUNNY NICKNAME IF YOU COULD SEE HIM. IF I COULD SEE HIM.
7. SWEET DO-NOTHING WITH LONG HAIR and LONG, LONG EYELASHES.
8. BARTENDER DOWN THE STREET. LATER, MY TATTOO ARTIST, DRUG DEALER, NUMBER-ONE SEXTER, and WEIRDLY PERFECT FRIEND.
9. GORGEOUS HEART-PIRATE WITH TIGER BEAT EYES. I SEXUALLY BLACKMAILED HIM OUT of GETTING A TATTOO of A SKULL BARFING OUT HIS FAVORITE THINGS: BEER, ELECTRIC GUITARS, SLURPEES.
10. ALL-too-SKILLED PHOTOGRAPHER.
11. EDITOR of THE "COOLEST" MAGAZINE. I WON'T MAKE THAT MISTAKE TWICE. I MEAN, I MADE IT MORE THAN TWICE, I JUST WON'T MAKE IT WITH ANYONE LIKE HIM AGAIN.
12. MY PRETTY, TOMBOY FRIEND. I WISH I'D SEEN HER NAKED, BUT THAT WASN'T HOW IT WENT DOWN.
13. DJ WHO LISTENED to MUSIC LIKE I READ BOOKS.
14. ANOTHER PHOTOGRAPHER, but LESS TALENTED. MORE BEAUTIFUL.
15. DUDE WHO CALLED ME "DUDE." RAD to THE BONE.
16. CHRIS, for WHOM I AM MY FAVORITE SELF, FOREVER.

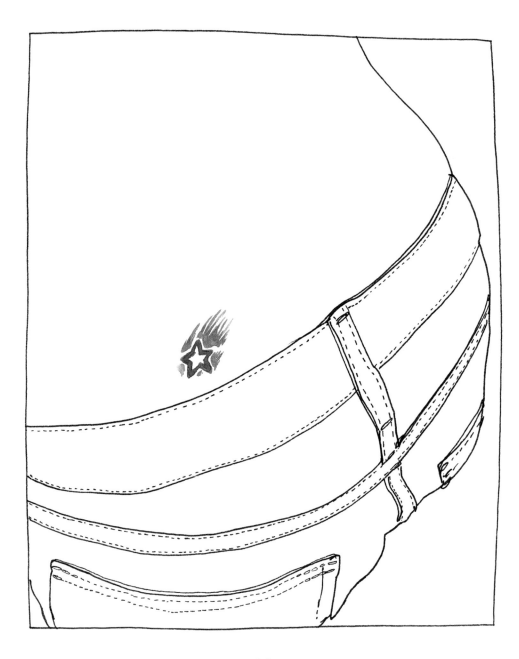

CLAIRE SALINDA, ADMINISTRATOR

I WAS FOURTEEN. A FRESHMAN in HIGH SCHOOL. MY MOM TOOK ME to SOMEPLACE on THE BOARDWALK in VENICE BEACH. SHE SAt ACROSS from ME and GOT A YIN-YANG. MY FIRST LOVE HAD BROKEN MY HEART, SO I NEEDED to DO SOMETHING DRAMATIC. IT'S A SHOOTING STAR to REPRESENT SOARING THROUGH THE HEARTBREAK, WHICH IS SO MELODRAMATIC... BUT I STILL BELIEVE IT. MOST PEOPLE THINK IT'S A BRUISE OR A SMUDGE of DIRT. I CORRECT THEM, BUT I DON'T TELL THEM THE WHOLE TRUTH. "I WAS FOURTEEN and A FRESHMAN in HIGH SCHOOL," I SAY. "MY MOM TOOK ME."

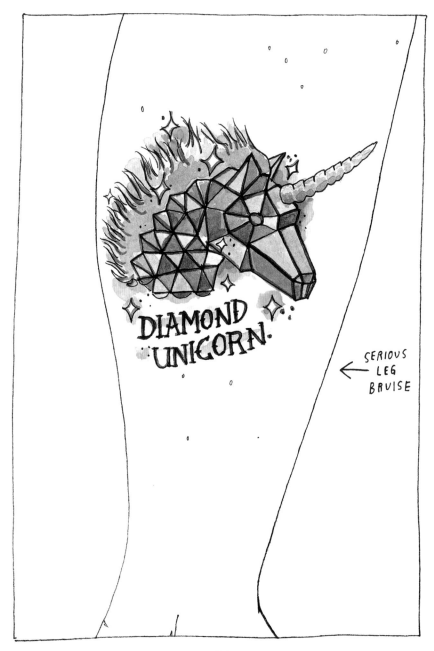

DIAMOND UNICORN.

SERIOUS
LEG
BRUISE

SAMARA PEPPERELL, GRAPHIC ILLUSTRATOR

"DIAMOND UNICORN" IS A ROLLER DERBY TERM to DESCRIBE A PARTICULAR SCORE in A GIVEN JAM.* THERE ARE SEVERAL LEVELS of UNICORNS: RAINBOW (10 GRAND SLAMS) BEING THE HIGHEST, CLOSELY FOLLOWED by DIAMOND (8 GRAND SLAMS) and THEN PLATINUM (7 GRAND SLAMS), THEN GOLDEN (6), and THEN JUST PLAIN UNICORN (5).

I ONLY KNOW ONE OTHER SKATER WHO HAS ACCOMPLISHED A DIAMOND UNICORN BESIDES MYSELF. HER NAME IS FRANCIE PANTS. AND I AM LADY TRAMPLE.

* A JAM IS A SHORT RACE BETWEEN TEAMS to SCORE POINTS.

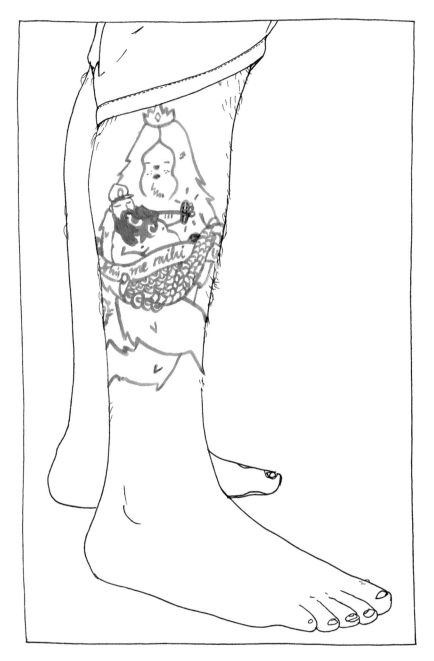

AARON GLASSON, CREATIVE DIRECTOR

IT'S A SHE-YETI CARRYING A MERMAN. A TATTOO THAT REPRESENTS MY GIRLFRIEND and ME. THOUGH SHE'S PHYSICALLY SMALLER, MY GIRLFRIEND HAS CARRIED ME THROUGH SO MUCH. SHE'S A FOREST LOVER and I'M A SALTY SEA DOG. WE HAD JUST GONE THROUGH AN ABORTION, and WE HAD AFFECTIONATELY CALLED THE FETUS "BABY BEAN." SHE (WE HOPED IT WOULD BE A SHE) IS SMILING, GRASPED in THE MERMAN'S ARMS as THE SHE-YETI RUNS THEM to THE SEA.

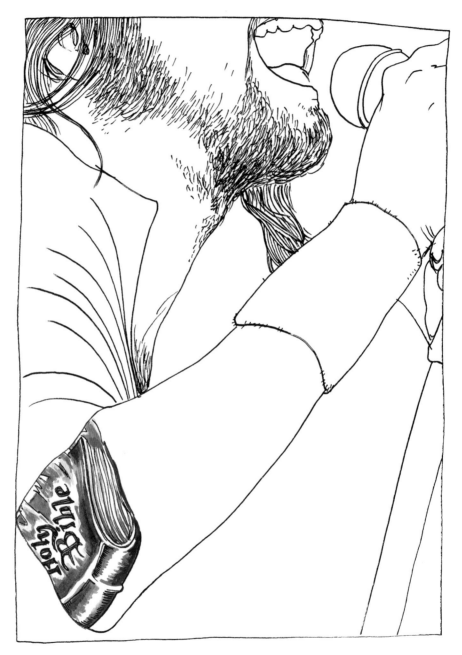

90

JONATHAN DAVIS, SINGER

THAT'S A BURNING BIBLE on MY ELBOW.
TRUE or NOT, THOSE WORDS ARE FOREVER
BURNED INSIDE MEN'S MINDS.

MICHELLE TEA, WRITER, and
DASHIELL LIPPMAN, ASSOCIATE DIRECTOR of SALES

ME and DASHIELL WANTED to GET SOME SORT of MATCHING TATTOOS BECAUSE WE'RE SO in LOVE WE JUST WANT to SCRIBBLE IT ALL OVER EACH OTHER'S SKIN. I'D HAD AN IDEA THAT GETTING HER NAME in SCRIPT on, LIKE, MY INNER THIGH WOULD BE REALLY HOT, and IT WOULD, but THEN I STARTED THINKING ABOUT WEARING BATHING SUITS and MAYBE IT WOULD BE A LITTLE TMI and ATTRACT UNWANTED ATTENTION to MY GROIN AREA, and ALSO THERE WAS THE FEAR THAT IT WOULD JUST LOOK LIKE PUBIC HAIR. I HAVE A LOT of MATCHING TATTOOS I'VE GOTTEN WITH FRIENDS, and I LIKE THEM BUT EVENTUALLY YOU'RE NOT REALLY CLOSE WITH THOSE PEOPLE and YOU DON'T SHARE THOSE SENTIMENTS ANYMORE and THEY JUST CLUTTER YOUR BODY. GETTING SOMETHING MATCHING DIDN'T FEEL SPECIAL ENOUGH, SO WE THOUGHT ABOUT TWO-PART TATTOOS and CAME UP WITH THE LOCK and KEY. WE UNLOCKED ONE ANOTHER, and NOW OUR HEARTS ARE LOCKED TOGETHER, FOREVER. WE'RE BOTH THE LOCK, and WE'RE BOTH THE KEY.

REBECCA WEINROTH, INTERIOR DESIGNER

GROWING UP I USED to MAKE MYSELF WEAR THIS LITTLE PLASTIC RING my MOM GAVE ME THAT HAD THREE HEBREW LETTERS ETCHED into IT. I HAD to HAVE IT WITH ME ALL THE TIME, BECAUSE EVER SINCE FOURTH GRADE I WAS ALWAYS SCARED THAT SHE MIGHT DIE from THE BRAIN TUMOR THEY FOUND AFTER SHE WAS RUSHED to THE HOSPITAL DURING MY VIOLIN RECITAL. I WAS ALWAYS SCARED THAT I WOULDN'T GET to HUG HER and SAY GOODBYE. BUT AS LONG AS I HAD THAT LITTLE PLASTIC RING IT FELT LIKE A PART of HER WAS STILL WITH ME and THAT EVERYTHING WOULD BE OKAY. AND IT WAS.

FAST FORWARD TWENTY YEARS LATER. SHORTLY AFTER MY THIRTIETH BIRTHDAY I MOVED from MY UPPER EAST SIDE MANHATTAN APARTMENT BACK into THE HOUSE WHERE I SPENT MY CHILDHOOD. IT WAS ONLY SUPPOSED to BE for A COUPLE MONTHS. INSTEAD I FOUND MYSELF SETTING UP SHOP INDEFINITELY for WHAT WOULD END UP BEING THE LAST YEAR of HER LIFE. I TOOK CARE of MY MOM LIKE SHE HAD TAKEN CARE of ME as A CHILD. I FED HER, BRUSHED HER TEETH, CUT HER NAILS, WIPED HER TEARS WHEN SHE'D CRY, and DID JUST ABOUT EVERYTHING and ANYTHING I COULD to KEEP HER LAUGHING - MADE SURE SHE FELL ASLEEP SMILING. ON SUNNY DAYS I'D ROLL HER WHEELCHAIR to THE BACK YARD and READ to HER— NOT MY USUAL READING MATERIAL, BUT BOOKS I FOUND on HER SHELVES UPSTAIRS, BOOKS on JUDAISM and SPIRITUALITY WITH THEIR PAGES FOLDED OVER, AS IF SHE WAS HOPING to GO BACK to IT ONE DAY. FLIPPING THROUGH A BOOK I LANDED on A PAGE WITH A CHART of SEVENTY-TWO COMBINATIONS of LETTERS from THE HEBREW ALPHABET. AND THERE in BOX NUMBER TWELVE WERE THE THREE HEBREW LETTERS THAT HAD BEEN ETCHED into THE RING SHE HAD GIVEN ME LONG AGO, WITH ITS MEANING UNDERNEATH: UNCONDITIONAL LOVE.

95

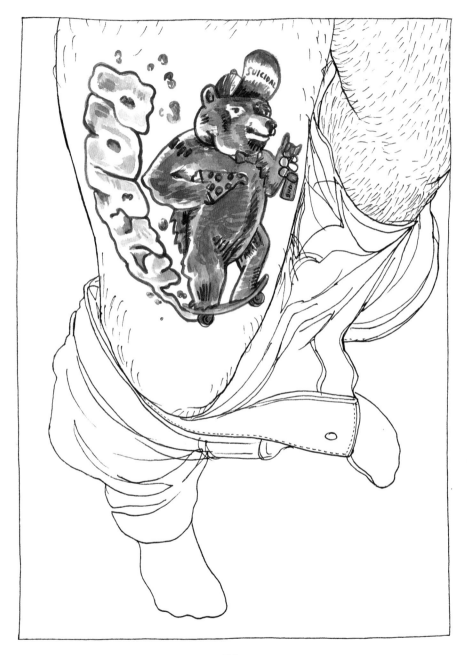

BRADY RICE, CO-OWNER at BRICK GUN RECORDS

I SHARE THIS TATTOO WITH TWO OTHER PEOPLE. ALL THREE of US WERE at A BAR WHEN THE IDEA HIT, and THEN THEY KEPT HITTING. IDEA AFTER IDEA AFTER IDEA. WE STARTED WITH A BEAR for THE OBVIOUS REASON: BEARS FUCKING RULE. THEN WE THOUGHT, WHY NOT PUT THE BEAR on A SKATEBOARD? ROCKING A MANUAL? WITH SMOKE COMING OFF THE TAIL THAT READS "PARTY"? WELL, IF YOU DO THAT, YOU MIGHT AS WELL THROW in A SLICE of PIZZA. (EACH of US CHOSE DIFFERENT TOPPINGS. I GOT PEPPERONI, BLACK OLIVES, and MUSHIES. DUH!) ONE MORE HAND to FILL. HAVE THE BEAR THROW A SHAKA WHILE HOLDING SIX-PACK RINGS WITH ONLY ONE BREW LEFT (BUDWEISER, OBVIOUSLY). DON'T FORGET to THROW A SICK BLACK FLAG TATTOO on THE BEAR'S BICEP. (NOW YOU'VE GOT A BLACK FLAG TATTOO on A TATTOO. SO META.) AND ANY SKATEBOARDER NEEDS A SUICIDAL TENDENCIES HAT, EVEN IF YOU HATE THE BAND, SO POP one of THOSE PUPPIES on TOP. ALMOST... BUT NOT QUITE. EVERY PARTY BEAR NEEDS A BOW TIE. THERE. PERFECT.

ANN FRIEDMAN, JOURNALIST, and
LARA SHIPLEY, PHOTOGRAPHER

IT WAS MARCH. ONE of US WAS SLOGGING THROUGH THE BREAKUP of A FOUR-YEAR RELATIONSHIP. THE OTHER HAD JUST WALKED IN on HER BOYFRIEND WITH ANOTHER WOMAN. WE TOOK A ROAD TRIP from KANSAS CITY to AUSTIN, WHERE WE PROCEEDED to GO on A FIVE-DAY BENDER. ON THE LAST DAY, AFTER CONSUMING COUNTLESS LONE STARS and DOWNING SEVERAL PITCHERS of MARGARITAS and MANAGING to LOSE TWO FLASKS in BARS, WE MADE OUR WAY to A TATTOO PARLOR WHERE WE SIGNED FORMS DECLARING WE WERE STONE-COLD SOBER. WE PRODUCED A WRINKLED COCKTAIL NAPKIN on WHICH WE'D DRAWN A LAUREL LEAF SURROUNDING A ROMAN NUMERAL "X" - THE NUMBER of YEARS WE'D BEEN FRIENDS. A GUY WITH A LONG GRAY BEARD INKED IT on EACH of OUR RIBCAGES. "I COMMIT to <u>YOU</u>," WE SLURRED to ONE ANOTHER as THE NEEDLE BUZZED. "I COMMIT to <u>YOU</u>."

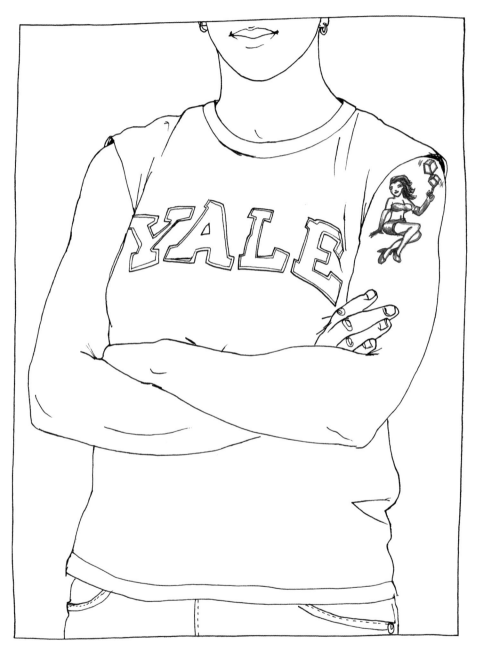

ALLYSON McCABE, PROFESSOR

I GOT THIS TATTOO SEVEN YEARS AGO. I WAS STUDYING GENDER THEORY and I DISCOVERED THAT THE ACADEMIC JOB MARKET WAS COLLAPSING JUST as I WAS FINISHING MY "CUTTING EDGE" DEGREE. MY COMPATRIOTS FLED to NONPROFITS, LAW FIRMS, EVEN INVESTMENT BANKS. I LANDED in ACADEMIC ADMINISTRATION. THE JOB PAID WELL, but LET'S FACE IT — IT ISN'T EASY to BE SUBVERSIVE WHILE SHUFFLING SPREADSHEETS in A CUBE. THEN ONE DAY LADY LUCK APPEARED, DEFIANTLY ANNOUNCING THROUGH MY SHIRT SLEEVES THAT THIS WAS GOING to BE A TEMP GIG. THE JOB ENDED. THE INK FADED. THESE DAYS I TEACH at YALE. BUT THE DICE HAVE KEPT on SPINNING. AND I AM STILL BECOMING SOMEONE ELSE.

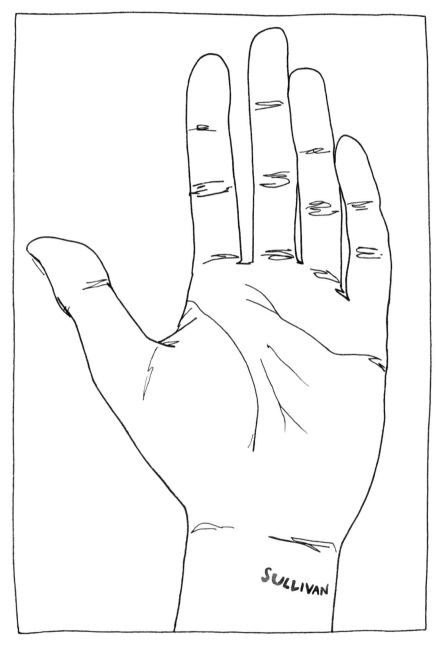

THAO NGUYEN, MUSICIAN

I MOVED ACROSS THE COUNTRY from MY FAMILY, NOT to BE FAR AWAY, BUT WITH NO CONCERN for BEING CLOSE.

I WAS A TACITURN FAMILY FRIEND. NOT A SISTER. NOT A DAUGHTER. BUT NO MATTER THE DISTANCE, A PART of ME WAS ALWAYS CERTAIN I WOULD COME BACK to BE AN AUNT.

ONE WEEK AFTER MY NEPHEW, SULLIVAN, WAS BORN I HAD HIS NAME on MY WRIST. THERE'S PLENTY of SPACE for ANY of HIS SIBLINGS WHO MIGHT FOLLOW.

IT'S BEEN ALMOST TWO YEARS NOW and I GO HOME to VISIT WHEN I CAN, NOT JUST to PASS THROUGH. I LISTEN, I ASK QUESTIONS, I COMMIT MY FAMILY to MEMORY, HOW THEY LIGHT UP, HOW THEY GRIMACE. I HATE THE TIME I WASTED, and I FEAR THE RATE of EVERYONE'S DISAPPEARANCE. NOW WHEN I LEAVE, THE DISTANCE BETWEEN US IS NOT NEARLY AS EXPANSIVE. OFTEN IT IS NO MORE THAN MY EYES to MY ARM. SHOULD I FORGET THAT I BELONG to PEOPLE, I HAVE SULLIVAN to REMIND ME.

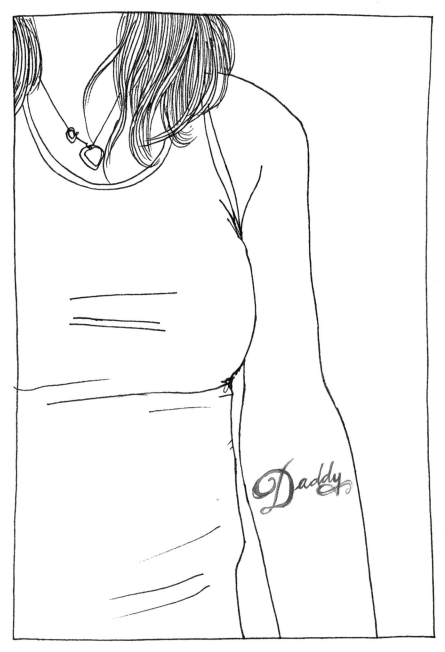

PRINCESS DONNA, ACTRESS/DIRECTOR/BDSM EDUCATOR

I DON'T KNOW HOW to TELL THIS STORY. ONE DAY MY DAD WAS ALIVE and WE WERE on VACATION and SWIMMING in THE OCEAN and MAKING MERMAIDS in THE SAND. AND THEN WE GOT BACK and I WAS at WORK and I GOT A CALL from MY MOM SAYING THAT THERE WAS AN AMBULANCE ON THE WAY to TAKE MY DAD to THE HOSPITAL. THE LAST THING I EVER HEARD HIM SAY WAS "WHO'S THAT?" MOM SAID, "IT'S ALI." DAD SAID, "I LOVE YOU, ALI. DON'T WORRY. I'M OK."

AND THEN I DROVE from SAN FRANCISCO to SACRAMENTO and HE NEVER WOKE UP and I RUBBED HIS FEET WHILE HE DIED. I WANTED to ALWAYS HAVE HIM WITH ME SO I MIXED HIS ASHES in WITH THE INK.

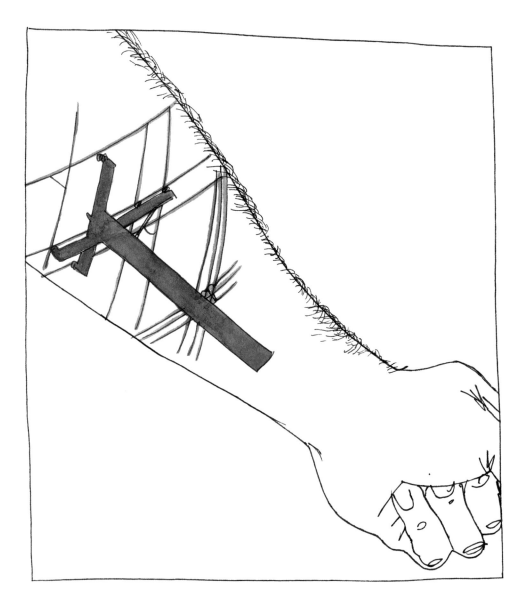

JASON PRADO, PROGRAMMER

FOR as LONG as I CAN REMEMBER, I'VE THOUGHT TELEPHONE POLES and POWER LINES WERE THE MOST BEAUTIFUL SCENERY in THE URBAN LANDSCAPE. NOW I WORK on SOFTWARE THAT MILLIONS of PEOPLE USE to COMMUNICATE. CONNECTING THE WORLD - WITH WIRES OR OTHERWISE - IS THE CENTRAL DRIVE of MY LIFE, and I'M REMINDED of IT EVERYTIME I LOOK DOWN as I TYPE OUT CODE.

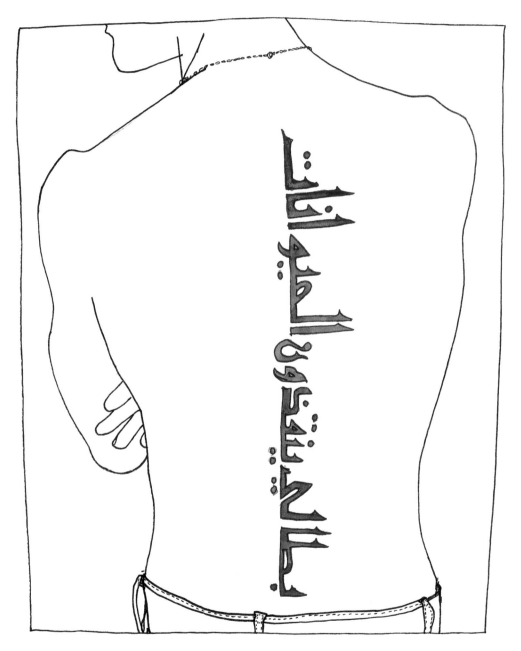

Caroline Paul, Writer

My brother had a secret life for twenty years as a member of the Animal Liberation Front. He was finally caught and sentenced to four years for burning down a horse slaughterhouse. I got this tattoo for him, while he was in prison. It's my only tattoo.

It says "My heroes rescue animals."

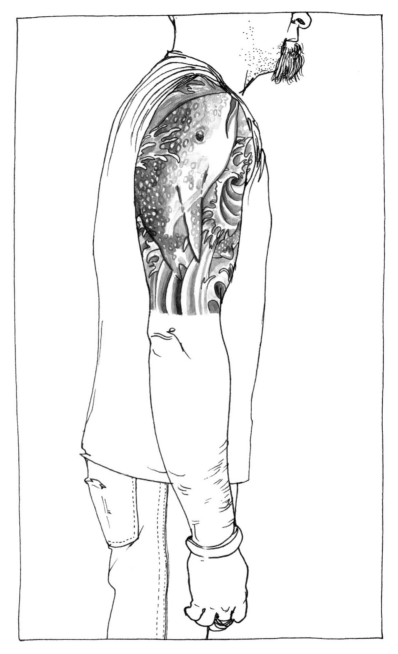

TODD WEINBERGER, CREATIVE DIRECTOR

MY GIRLFRIEND and I HAD BECOME OBSESSED WITH WHALE SHARKS, SO WE TRAVELED to THE YUCATÁN PENINSULA, to ISLA HOLBOX, WHERE WHALE SHARKS OFTEN MIGRATE in SEARCH of PLANKTON. WE WERE PICKED UP ON A BEACH at DAWN, and TRAVELED AN HOUR to THE MIDDLE of THE CARIBBEAN SEA. ON OUR WAY, WE PASSED THREE "BABY" EIGHTEEN-FOOT WHALE SHARKS, and THEN CAME ACROSS FIVE THIRTY-FOOT FEMALES and TWO NINE-FOOT MANTA RAYS. WE DROPPED ANCHOR and JUMPED IN, SWIMMING WITH THESE GIANT CREATURES, in AWE of THEIR SIZE and GENTLENESS. THEY WERE AWARE of US, BUT WERE NEITHER STARTLED NOR SCARED. IT WAS THE GREATEST, MOST PEACEFUL MOMENT of MY LIFE and I WANTED to REMEMBER IT FOREVER.

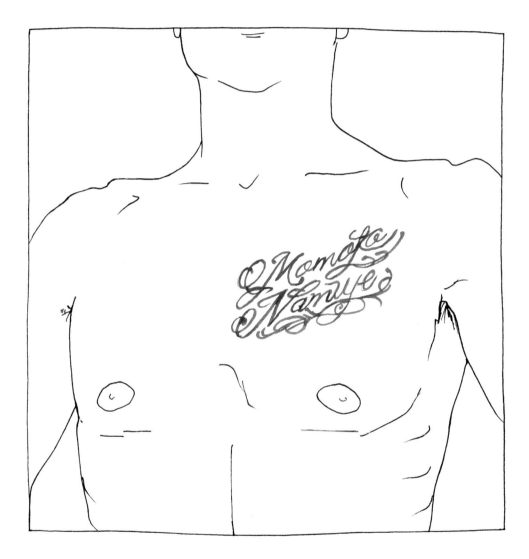

KIYOSHI NAKAZAWA, CARTOONIST and BOUNCER

I HAVE THE NAMES of MY DAUGHTERS, MOMOKO and NAYIME, TATTOOED ACROSS MY HEART. THEIR MOTHER, MY THEN WIFE, HAD JUST ASKED for A DIVORCE and THE ISSUE of CUSTODY WAS STILL in THE AIR. I KNEW THAT THE CASE WOULD END in A 50/50 DEAL, WHICH IS WHAT WE BOTH SAID WE WANTED, BUT THE THOUGHT of WHAT MY KIDS WERE GOING THROUGH, WOULD GO THROUGH, CONTINUALLY CRUSHED MY HEART. I WANTED to HAVE THEIR NAMES on ME for THE DAYS I WOULDN'T BE WITH THEM. I WANTED THEM to SEE HOW IMPORTANT THEY ARE to ME. THERE WILL NEVER BE A WOMAN'S NAME TATTOOED on MY BODY OTHER THAN THE NAMES of MY DAUGHTERS.

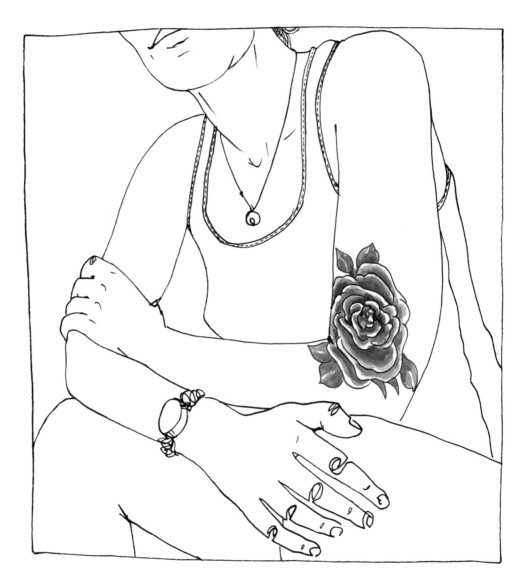

MARIE McINTOSH, PUBLIC ENGAGEMENT MANAGER

WHEN I WAS 24, I WAS TREATED for VAGINISMUS, A PELVIC PAIN DISORDER THAT TOOK ALMOST THREE YEARS to DIAGNOSE. THE MENTAL ANGUISH THAT CAME WITH SEXUAL DYSFUNCTION WAS ALMOST WORSE THAN THE PAIN ITSELF, and LEFT ME FEELING FRUSTRATED WITH A MEDICAL COMMUNITY UNABLE to FIND THE ROOT of THE PROBLEM. THIS TATTOO SERVES AS A TRIBUTE to THE MOST VITAL of MY ORGANS, THE PART of MY ANATOMY I AM NO LONGER AFRAID to SPEAK FRANKLY ABOUT, and THE GROWTH THAT COMES WITH HEALING.

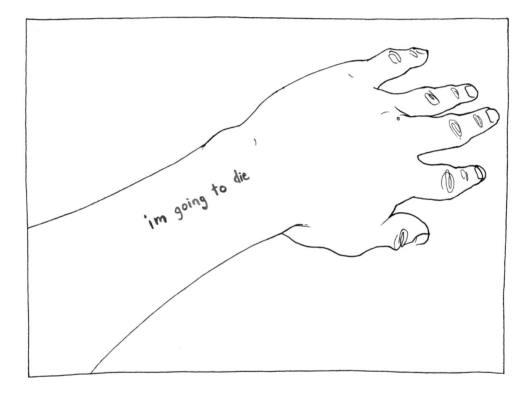

TAO LIN, WRITER

I WAS WITH MY FRIENDS ELAINE and SPENCER WHEN, AFTER GETTING A DIFFERENT TATTOO, I GOT THIS ONE IMPULSIVELY. I THINK IT WENT LIKE THIS: (1.) AFTER ELAINE and I GOT OUR TATTOOS and PAID, SPENCER HADN'T DECIDED WHAT, IF ANY, HE WANTED (2.) I BEGAN SAYING IDEAS ALOUD (3.) I PROBABLY SUGGESTED "I'M GOING to DIE" as "A GOOD ONE" (4.) I PROBABLY SAID "I SHOULD JUST GET THAT MYSELF" WHILE THINKING THAT "I HAD TO" (5.) I GOT IT.

ITS MESSAGE, to ME, IS SOMETHING LIKE "YOU'RE GOING to DIE, SO STOP BEING SAD; START DOING WHAT, from THE PERSPECTIVE of BEING DEAD, YOU'D WANT YOUR PAST SELF to HAVE DONE"— A MESSAGE I BECAME TOLERANT to WITHIN PROBABLY 3-4 DAYS. BUT I REMEMBER ONE INSTANCE, PROBABLY on DAY 1 or 2, WHEN IT WORKED. I WAS WASHING MY HANDS WHEN, NOTICING MY TATTOO and INTUITING ITS MESSAGE, I FELT MOTIVATED to DO LAUNDRY IMMEDIATELY. I DRIED MY HANDS and, TO my MILD SURPRISE, INSTEAD of GOING to MY MACBOOK to ABSENTLY REFRESH WEBSITES REPEATEDLY and, at SOME POINT, PROBABLY MASTURBATE, as HAD VAGUELY BEEN my PLAN, I DID LAUNDRY.

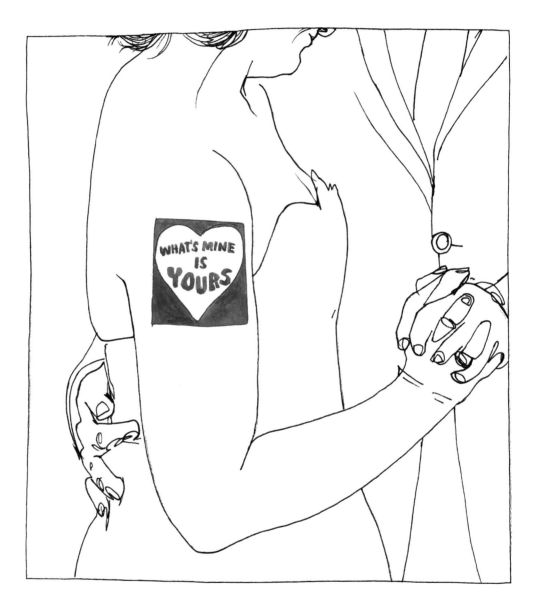

MICHELLE CROUCH, PUBLIC RADIO INTERN

I USED to RIDE THE MARKET-FRANKFORD LINE ALL THE WAY WEST to GET to WORK. AFTER 46th STREET THE TRAIN RUNS on AN ELEVATED TRACK and AS I RODE to THIS JOB I HATED, COLORFUL MURALS BEGAN POPPING UP at EYE LEVEL. THEY SAID THINGS LIKE "YOUR EVERAFTER IS ALL I'M AFTER" and "HOLD TIGHT" and "WHAT'S MINE IS YOURS." THEY CHEERED ME UP. ONCE, on MY DAY OFF, I WALKED from 46th to 63rd STREET as A SORT of PILGRIMAGE and MET THE ARTIST WHO GREETED ME from A CRANE AS HE PAINTED THE LETTERS "W-A-N-T" on A BRICK WALL. WHEN I HEARD HE WAS DESIGNING A SERIES of TATTOOS BASED on THE LOVE LETTER MURALS, I DECIDED to GET ONE. A GUY I'D JUST STARTED DATING ACCOMPANIED ME to THE TATTOO SHOP. I PICKED OUT "WHAT'S MINE IS YOURS." THE WORDS REMIND ME to BE GENEROUS. I TRY to LIVE THEM EVERY DAY. NOW I HAVE A JOB I LIKE and I'M MARRIED to THAT BOY I HAD JUST STARTED DATING. MARRIAGE STRIKES ME AS BEING A LOT LIKE THE TATTOO — ANOTHER WAY of MAKING GENEROSITY PERMANENT.

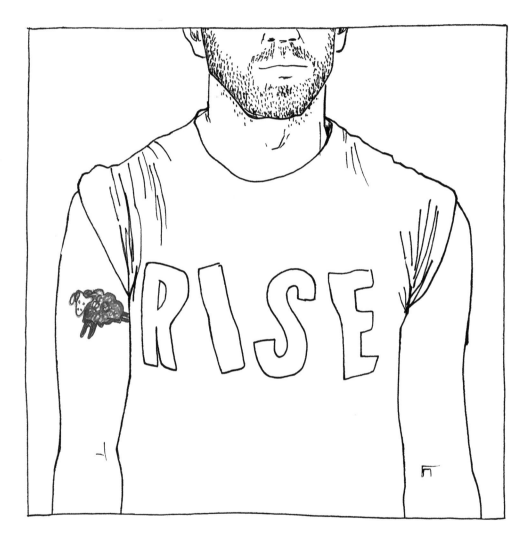

TIM McILRATH, MUSICIAN

I TOOK A TRAIN, ALONG WITH OUR GUITAR/
BASS PLAYER, OUT to LONG ISLAND to MEET
ANTHONY "CIV" CIVARELLI from GORILLA BISCUITS.
WE WERE SUPER LATE, BUT CIV STILL TOOK THE
TIME to TATTOO THE MINOR THREAT SHEEP ON BOTH
of US. THE BLACK SHEEP IS SUCH AN ICONIC
TATTOO- and TO HAVE A PUNK LEGEND
LIKE CIV TATTOO IT ON ME JUST MADE IT
THAT MUCH SWEETER.

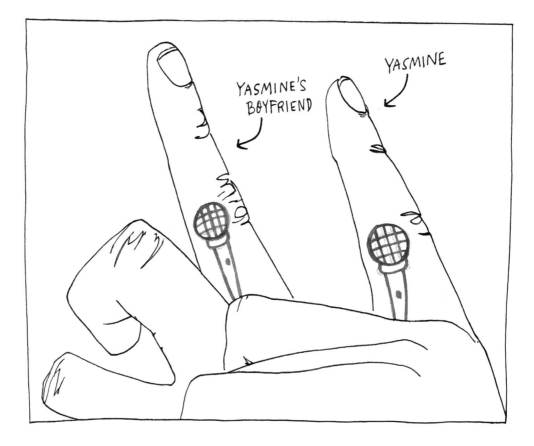

122

YASMINE HAMDOUCHE, GRADUATE STUDENT
(and BOYFRIEND)

MY BOYFRIEND IS LOUD; I AM NOT. HE SINGS WITHOUT FEAR; I FEAR SINGING. WITH THAT GIVE and TAKE, I'VE LEARNED HOW to AMPLIFY MY OPINIONS and MAKE MY THOUGHTS HEARD. THE MICROPHONE on THE INSIDE of MY LEFT INDEX FINGER REMINDS ME THAT I ALWAYS HAVE THE MIC, and WITH IT THE VOICE to SPEAK FREELY and WITHOUT INHIBITION.

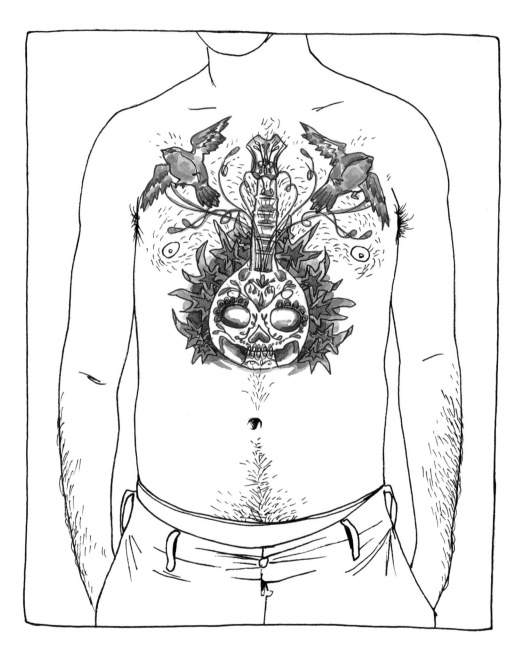

CLAMS ROCKEFELLER, PRODUCTION DESIGNER

I GREW UP WATCHING MY FATHER PLAY HIS MANDOLIN in BARS, CONCERTS, and MUSIC FESTIVALS AROUND THE COUNTRY. IT WAS A MAGNIFICENT INSTRUMENT THAT HE BUILT HIMSELF BEFORE HE EVEN KNEW HOW to PLAY. WHEN HE APPLIED for A JOB at THE GUILD GUITAR FACTORY, HE BROUGHT THE MANDOLIN in PLACE of A RESUME and HE WAS HIRED ON THE SPOT.

MY DAD PASSED AWAY UNEXPECTEDLY at THE AGE of FIFTY-THREE. FRIENDS and OLD BANDMATES, MANY of WHOM I HAD NEVER KNOWN, CAME OUT of THE WOODWORK for HIS MEMORIAL SERVICE. WE SAT and LISTENED to MY FATHER'S MUSIC. I CAN'T EXPLAIN HOW POWERFUL IT IS to HEAR THE VOICE and PASSION of SOMEONE YOU'VE OTHERWISE LOST.

LIKE THE MEXICAN TRADITION of DIA de LOS MUERTOS, WHICH MY PARENTS HAD TAUGHT ME AS A CHILD, MY FATHER'S FUNERAL WAS A CELEBRATION of HIS LIFE and ACHIEVEMENTS RATHER THAN A MOURNING of HIS PASSING. I FELT LIKE A TRADITIONAL DAY of THE DEAD SKULL, COMBINED WITH MY FATHER'S PRIZED MANDOLIN, WOULD BE AN APPROPRIATE TRIBUTE to BOTH HIS DEATH and LIFE. THE TATTOO IS AN EFFECTIVE and CONSTANT REMINDER of THE PERSON I WANT to BE. A PERSON LIKE MY FATHER.

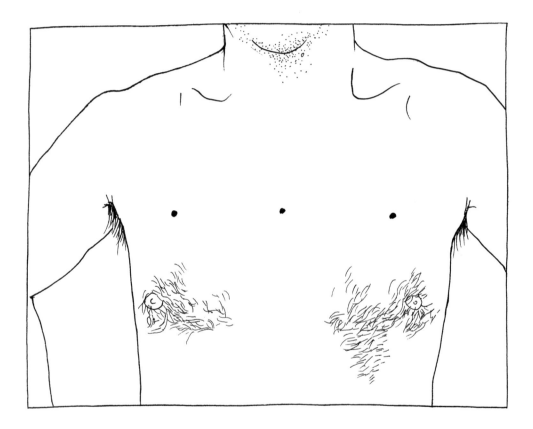

CRAIG DALTON, BUSINESS OWNER

I HAVE THREE DOTS TATTOOED on MY CHEST. YES, DOTS. EACH NO BIGGER THAN A FRECKLE. NOT EXACTLY THE TYPE of THING YOU SEE at A TATTOO SHOW. THEY ARE A PERMANENT REMINDER of THE RADIATION THERAPY I RECEIVED in 2002 to TREAT HODGKIN'S LYMPHOMA AFTER A THREE-MONTH COURSE of CHEMO. IN ORDER to LINE UP THE RADIATION MACHINE PRECISELY EVERY TIME, PATIENTS ARE TATTOOED. WHEN I PLACE MY HANDS at MY HIPS THE THREE DOTS FORM A PERFECT LINE. TODAY, I'M A PROUD CANCER SURVIVOR WITH THE LEAST ARTISTIC TATTOOS AROUND.

ARTISTS and PARLORS

Chris Colin, original tattoo by Unknown Artist, "somewhere in the Haight in San Francisco."

Anna Schoenberger, original tattoo by "a dude named Ken on Hollywood Boulevard . . . I have no idea if that place is even there anymore."

Mikael Kennedy, original tattoo by "Chuck from Atlanta."

Raymond "Shrimp Boy" Chow, original tattoo by 007 in Tehachapi State Prison.

Kyle Kinane, original tattoo by "some racist in Pasadena. I don't remember his name."

Cassy Fritzen, original tattoos by Jeff Rassier at Black Heart Tattoo in San Francisco.

Evan Jones, original tattoo by Unknown Artist at Capitol Tattoo Ink in Washington, D.C.

Christine Hostetler, original tattoo by "a French artist who goes by 'G'" (no other information available at G's request).

Nick Turner, original tattoo by Crystal Puckett at Newport Tattoo in Newport Beach.

Morgan English, original tattoo by Expanded Eye at Needles Side Tattoo in Thonon-les-Bains.

Roxane Gay, original tattoos by "assorted artists at assorted shops."

Andrea de Francisco, original tattoo by Erik Jacobsen at Idle Hand Tattoo in San Francisco.

Emily Cable, original tattoo by Lewis Hess at Atlas Tattoo in Portland.

Joshua Mohr, original tattoo by Kelley Premeaux at Tattoo 23 in Austin.

Carson Ellis, original tattoo by Carson Ellis "in the art room during lunch."

Kirsty Logan, original tattoo by Morag Sangster at Tribe 2 Tattoo in Glasgow.

Mac McClelland, original tattoo by Sam McWilliams at Black and Blue Tattoo in San Francisco.

Ryan M. Beshel, original tattoo by Josh Howard at Pioneer Tattoo in Chicago.

Mona Eltahawy, original tattoo design drawn by Molly Crabapple and tattooed by Dave Wallin at Eight of Swords Tattoo in Brooklyn.

Kriste York, original tattoo by Denise of Idyll Hands in Corvallis.

Alexis C. Madrigal and Sarah C. Rich, original tattoos by Hannah Wednesday at Tuesday Tattoo in San Francisco.

Alise Alicardi, original tattoo by Denny Besnard at Avalon II Tattoo in San Diego.

Anthony Ha, original tattoo from Black and Blue Tattoo in San Francisco.

Yuri Allison, original tattoo from Le Studio in Rennes.

Susie Cagle, original tattoo by Gordon Combs at Seventh Son in San Francisco.

Erin Bechtol, original tattoo from Cosmic Creations Tattoo in South Lake Tahoe.

Dmitry Samarov, original tattoo by Eric Doyle, "who normally works out of Jinx Proof in Washington, D.C., but was visiting Chicago and tattooing at Tony Fitzpatrick's studio."

Eric Fletcher, original tattoo by Andrew Milko at Liquid Courage Tattoo in Omaha.

Siobhan Barry, original tattoo by Taler Nicols at Let It Bleed Tattoo in San Francisco.

Alexa Suess, original tattoo by Becca Roach from North Star Tattoo in Manhattan.

Lisa Congdon, original tattoo by Cicely Daniher at Cyclops Tattoo in San Francisco.

Melissa Chadburn, original tattoo by Shannon Archuleta at Cold Steel America in San Francisco.

Sarah Nicole Prickett, original tattoo by Kris Sharon at TCB Tattoo in Toronto.

Samara Pepperell, original tattoo by Nick Agnew at Kingsland Ink in Auckland.

Aaron Glasson, original tattoo design drawn by Aaron Glasson and Liam Moore and tattooed by Dee Pitman at Kingsland Ink in Auckland.

Michelle Tea and Dashiell Lippman, original tattoos from Spider Murphy's Tattoo in San Rafael.

Rebecca Weinroth, original tattoo from New York Adorned in Manhattan.

Brady Rice, original tattoo design drawn by Aaron Bo Heimlich and tattooed by Taler Nicols at Let It Bleed Tattoo in San Francisco.

Ann Friedman and Laura Shipley, original tattoos from True Blue Tattoo in Austin.

Allyson McCabe, original tattoo by Chris Keaton at the Baltimore Tattoo Museum.

Jason Prado, original tattoo by See See Kwan at Deep Roots Tattoo in Seattle.

Caroline Paul, original tattoo by Mike at Black Heart Tattoo in San Francisco.

Todd Weinberger, original tattoo by Chris O'Donnell at Saved Tattoo in Brooklyn.

Kiyoshi Nakazawa, original tattoo by Adam Warmerdam at Dark House Tattoo in Hollywood.

Marie McIntosh, original tattoo by Jason Stein at Cyclops Tattoo in San Francisco.

Michelle Crouch, original tattoo (based on the art of Steve Powers) by Bashir at Northern Liberty Tattoo in Philadelphia.

Yasmine Hamdouche, original tattoo(s) by Iggy Vans at Idle Hand Tattoo in San Francisco.

Clams Rockefeller, original tattoo by Andrew Milko at Liquid Courage Tattoo in Omaha.

Craig Dalton, original tattoo by the radiation specialists at the University of California, San Francisco.

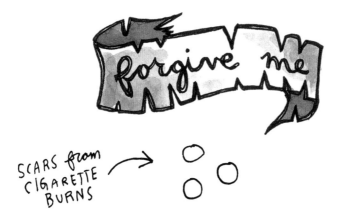

SCARS from CIGARETTE BURNS →

ISAAC FITZGERALD'S THIRD TATTOO WAS CUT INTO HIS ARM WITH A HOMEMADE TATTOO GUN on AN ISLAND TEN MILES OFF THE COAST of NEW HAMPSHIRE. THE IDEA BEHIND THE TATTOO, WHICH RESTS ABOVE THREE CIGARETTE BURNS, WAS SOME GRASP at CATHOLICISM, FORGIVENESS, and THE HOLY TRINITY. IT'S KIND of HARD to REMEMBER, THOUGH, BECAUSE of ALL THE WHISKEY. LIFE MISTAKES ARE ISAAC'S CO-PILOT.

WENDY MacNAUGHTON'S FIRST TATTOO WAS DRAWN
and INKED WHEN SHE WAS NINETEEN. IT IS ON HER
LEFT FOREARM. IT WAS A DIAGRAM of HER ARGUMENT
AGAINST PSYCHOANALYST JACQUES LACAN'S THEORIES.
THOUGH SHE WAS PROBABLY WRONG, WHAT THE TATTOO
DOES PROVE IS THAT WENDY, LIKE MANY NINETEEN - YEAR-
OLDS, USED to TAKE THINGS WAY too SERIOUSLY, and
THAT THANKFULLY, THINGS CHANGE.